12 —

12 —

Charles F. Hamilton is Director of the Photography/Multi-Media Department at the Art Institute of Pittsburgh. He is also executive vice-president of Faster Than Light Industries, Inc., and has past experience in commercial, technical, and advertising photography, and in teaching photography.

PHOTO GRAPHING NUDES

CHARLES F. HAMILTON

A SPECTRUM BOOK

Prentice-Hall, Inc., Englewood Cliffs, N.J. 07632

Library of Congress Cataloging in Publication Data

Hamilton, Charles F.
 Photographing nudes.

 (A Spectrum Book)
 Includes index.
 1. Photography of the nude. I. Title.
TR674.H35 1980 778.9′21 79-2540
ISBN 0-13-665273-5
ISBN 0-13-665265-4 pbk.

A SPECTRUM BOOK

Printed in the United States of America

10 9 8 7 6 5 4 3 2 1

Editorial/production supervision by Maria Carella
Art director: Jeannette Jacobs
Manufacturing buyer: Cathie Lenard
Cover photograph by the author

PRENTICE-HALL INTERNATIONAL, INC., *London*
PRENTICE-HALL OF AUSTRALIA PTY., LIMITED, *Sydney*
PRENTICE-HALL OF CANADA, LTD., *Toronto*
PRENTICE-HALL OF INDIA PRIVATE, LIMITED, *New Delhi*
PRENTICE-HALL OF JAPAN, INC., *Tokyo*
PRENTICE-HALL OF SOUTHEAST ASIA PTE., LTD., *Singapore*
WHITEHALL BOOKS, LIMITED, *Wellington, New Zealand*

CONTENTS

STRUCTURAL APPLICATIONS

PREFACE

In order to be successful, any photographic print must first gain the viewer's attention either by content, technique, visual structure, or any combination of these elements. A nude photograph usually has enough inherent content to gain attention. But follow this content up with strong leading lines and an appropriate light form and you have also gained the viewer's confidence as well as curiosity.

The orientation of this book is on lighting technique and visual structure. It is based on exercises which could apply to many other areas of photography. The emphasis, nonetheless, is placed upon the human body because the instrinsic qualities of the nude provide all that is necessary to form the perceptional basis of still photographic rendering. It has been stated that a photographer who can illuminate and render a richly realistic skin tone in black-and-white photography can be expected to deal with almost any other photographic subject well. And with what other subject do you have such vast expanses of skin tone to render? The complexity of the body magnifies design and lighting principles as no other subject matter can, while the many planes lend themselves well to exercises in simplicity that become real challenges. In these respects, the successful nude photograph becomes a real display of mastery. Least of all, the nude is pleasant subject matter and admittedly more exciting to most photographers than photographing a box of corn flakes.

As with the many directions in photography, there are no absolute rights or wrongs—just different ways of approaching any given situation. The information and illustrations in this volume are, for the most part, basic and represent one approach. Consider them as stepping-off points for your own innovations.

ACKNOWLEDGMENTS

Thanks to Charles Casler, Barbara Grauel, Sharon Merrell, John Simpson, and a number of photographers for their contributions. (All photos not credited are by the author.)

In particular, I would like to thank Ms. Jane Dumire, Fairmont State College, to whom I am indebted for encouragement in the field of education.

C. Hamilton

A BRIEF
HISTORY

There are many in the academic world who could devote pages of copy around the aesthetics and values to be gained while using the nude in photographic training. It is a fact that most schools offering photography programs also offer some form of a nude workshop. Why? To be certain, some institutions make the offering merely to follow a trend or to sell a program, but most do realize the educational value of working with the human figure.

For whatever the original intent, the photographer has been recording the nude on film for as long as technical advancements have permitted exposure times of anything shorter than an hour.

THE BEGINNINGS

Since study of the human figure had been historically accepted for the painter, the first photographic images of nudes were requested and sold for points of reference for the painter. The "rules" for nude work and other photographic subjects were initially based on paintings that for the most part were created between the early 1500s and mid-1800s. Nude photographs of this early period are best characterized by the women appearing to be rigidly but lavishly posed, painfully smiling at the camera for extended periods of time—obviously wishing for faster film emulsions to be developed.

Planned or unplanned, the market quickly evolved from the painter's aid to a big-money business geared primarily to the nonartist in the form of glamour photography. Influenced heavily by the notoriety of the French postcard photography, the new trend featured large-hipped, full-figured women often awkwardly photographed against hand-painted backgrounds, sometimes with elaborate props, in cheesecake-type, sexually suggestive poses. The end of World War I marked an international boom for this mildly pornographic product. The war had changed women's role in society and the male population supposedly sought the former female image. Almost innocently coy, the nude female images of this period at least remain as examples of a more honest approach to photography's true qualities—truer at least than the "art" or pictorialist photographer's counterpart. With this latter group, any and all artistic inclinations were satiated by a soft-focus, already-dated painterly pictorial approach both in the studio and in the environment.

Neither approach, however, much enhanced nude photography in breaking from the past ties of art rules which so rigidly confined the new medium to forms of criticism that had not been necessarily valid to either painting or photography for many years. Basic photographic properties remained largely unnoticed by photographer and

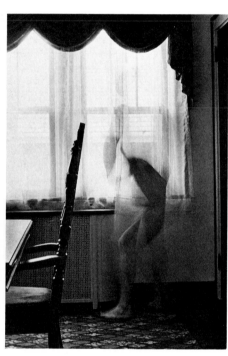

viewer alike. There was little awareness, for instance, of how the nude could be interpreted by its new size, its translation into tonal values, and its unique perspective. At least not until Edward Weston focused his large-format cameras critically on the nude form.

A NEW VISION

The photographic purist position partially adopted by Weston was based on the premise that photography has unique qualities apart from other mediums and that the value of any photograph is directly dependent on fidelity to these qualities. His nude studies were a radical departure from the traditional painting-emulating studies. Every pore and hair follicle was rendered crisply and objectively—forming honest records of earthy and always real women.

The early 1950s marked a new period where gracefully exaggerated dance poses, nonrevealing silhouettes, and other veiled approaches highlighted the photographic nude that was conspicuously displayed without any sign of a pubic area. Did the viewing audience really believe that the camera had the power to eliminate pubic hairs, or were they aware that behind the scenes artists were busy eradicating hair as quickly as the new technology could render them?

Fortunately, this period of regression was short-lived as the public became aware that indeed photographs as well as the written word can and do lie. To bring some belief to the credibility gap, a period of shock value based on the superreal followed where it appeared as though the airbrush artist must have replaced all of the missing pubic areas and then some. Blunt realism placed the nude, both male and female, in carefully structured environments . . . in surrealistic environments . . . forming their own environments with body landscapes . . . and as an object of heightened realism with the documentary photographer's approach. Cut-and-paste collages, manipulated montages, multiple exposures, and the purist approach explored the nude body as in no other period.

What generalizations can be made about contemporary nude photography and future directions? The photographer is no longer restricted by technical limitations. Fast, fine-grained films, sophisticated artificial light sources, combined with a wide selection of versatile cameras—many with fully automated exposure control—now permit the photographer to explore the nude under any conceivable condition.

ebra P. Romanchak.
atural light is correct in any of its various forms. Many
hotographers feel that light passing through a window is
e most beautiful source of illumination for rendering
kin tone.

LIGHTING

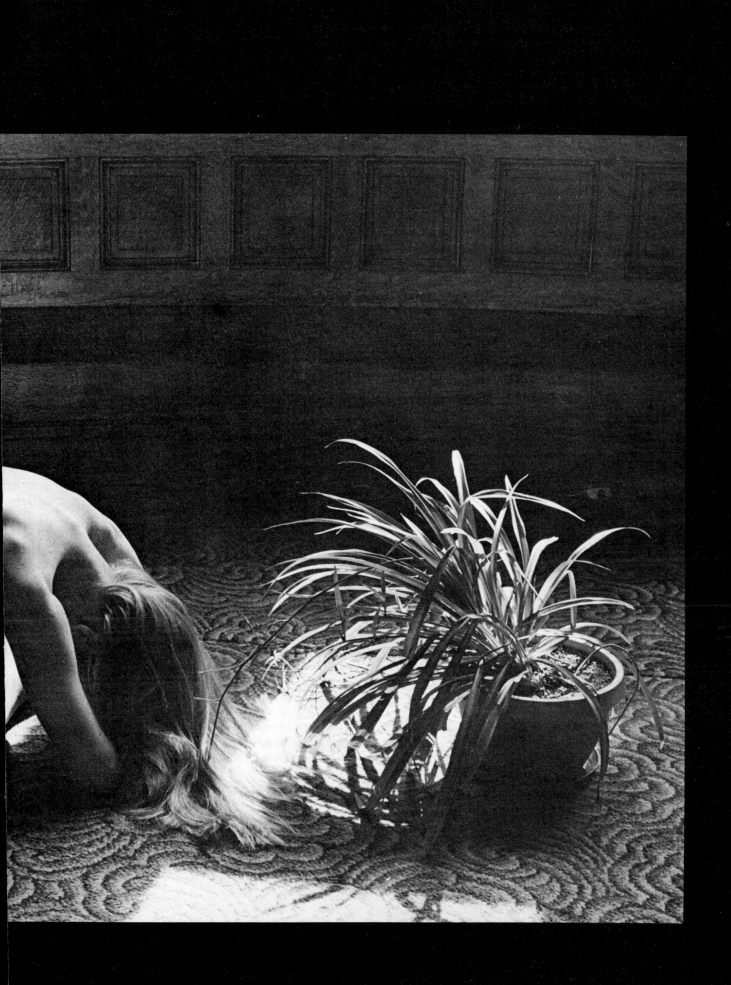

Samuel J. Gentile.
Although artificial light application
requires considerable practice, it offers
the ultimate in control and a number
of light forms otherwise unobtainable.

Awareness and control of light constitute the most critical step in creating a successful nude image. The inherent beauty of the nude can oftentimes produce pleasing lines even with the crudest compositional approaches of the unthinking photographer. Without at least a sensible approach to light, however, the photographer is capable of turning even the most beautiful of models into something approaching raw meat in cold storage. Modern cameras are capable of doing many things for the photographer—that is, anything except thinking. Light is still the foundation on which the photographic image is formed, and to master it successfully requires thought and practice. Light alone stands as the deciding factor between mediocrity and sensitivity. No mechanical devices or even raw luck can pull the photographer through.

Technical knowledge alone cannot produce light awareness. The photographer must learn to "see" light. Only continued study of light forms, light application, and reevaluation can develop a sensitivity that separates the photographers from the would-be photographers. Comprehension of light is the basis of good lighting and, consequently, good photography.

NATURAL VERSUS ARTIFICIAL LIGHT

Natural or artificial light? Often this decision must be based on convenience or necessity. Most of the time personal style or preference dictates the choice.

NATURAL LIGHT

Sunlight is a natural choice for many photographers. It is "the" safe source, as it is almost always correct in any of its various forms. Sunlight provides an excellent illumination to study because artificial light is based on the sun—although you may eventually find yourself looking for the more controllable studio conditions in natural environments.

Sunlight can provide an extremely broad, even source that is extremely bright in relation to any of the artificial sources. Natural illumination is never monotonous, as it offers a wide variety of lighting conditions to explore, ranging from broad, diffuse open shade to intensely directional sunlight.

10

ARTIFICIAL LIGHT

Artificial light, theoretically, offers the ultimate in light control. The photographer can easily change the position and direction of the light source. A broad, diffuse source can be changed to a point source in seconds. And it does not matter whether it is raining or snowing, for artificial light sources are never dependent upon weather conditions.

DISADVANTAGES OF BOTH

Unfortunately for the beginner, artificial lights are not so easily controlled or predictable. They tend to be extremely hard for prediction of results, and images do not record exactly as they appear, or so it often seems. Controlling artificial light requires considerable practice prior to the ideal predictability.

But with natural light, weather is the real unpredictable factor. Schedule a model for Thursday afternoon and take your chances on the availability of the sun. Is this what is meant by available light? Rather than moving a light source with natural light conditions, the photographer must move the subject and camera position to gain any degree of control—and all the while worrying whether there are enough daylight hours to get the shooting completed. And what about that beautiful light form you saw in that same location . . . yesterday?

To every advantage there is a disadvantage to either natural or artificial illumination. But learning to see light is the problem at hand. Whatever source you choose, do not make the choice out of mere convenience or ignorance of the other form.

Positioning of the main light plays highlights against shadows to create the illusion of dimensional qualities—much as the eye sees in the real world.

THE MAIN
LIGHT SOURCE

Basic lighting principles are universal to all light sources. To begin quite simply, first accept the fact that there is only one main light source, be it the sun or its studio equivalent. If this sounds rather basic to many of you, rest assured that most of the problems in understanding light are due to ignoring basic facts. You must learn to really observe the main source of illumination falling on your nude model, paying particular attention to what is actually happening in front of you. Learn to see what is occurring and what will always occur regardless of whether you are in a studio or working with natural light. You will discover that the main light creates the entire mood of your photography and defines four basic qualities upon which all images depend: three-dimensional modeling, separation of planes, a cast shadow, and textural rendering.

MODELING

A photograph is a two-dimensional representation of a three-dimensional world; therefore, it becomes necessary to create the illusion of a third dimension in order for it to appear natural. The illusion of mass or volume in any solid object in a photograph must be formed. By placing the main light source in a position where highlights are played against shadows, dimensional qualities appear to be rendered much like the eye would see them in the real world. This illusion of three-dimensional rendering is referred to as *modeling,* and the subject in the photograph assumes the appearance of natural form.

The nude form is modeled when the complex series of body planes are defined and separated by the direction of the main light. A frontal, head-on light shows little if any dimensional qualities. As the light is moved in an arc around the nude, modeling effects are gradually increased until one-half of the figure is in highlight and the other is in shadow. At this point modeling and the consequent illusion of dimension is at the maximum. Continuing to move the main light in the same direction, the highlight areas will decrease while the shadow areas increase until the light is directly behind the model and nothing but a silhouette is rendered.

It is accepted that, when photographing a model in natural light, a cast shadow is as natural as the sun. But with an artificial light source, most beginning photographers attempt to eliminate shadows. Shadows falling upon important parts of the nude are distressing; however, cast shadows are inherent with any light source and are desirable. What is objectionable is unpleasant shadows or more than one cast shadow. Several shadows, or cross-shadows, coming from light in opposing directions are not natural and should be avoided. Multiple shadows indicate multiple light sources, and it is accepted that there is only one main light source, be it the sun or the studio equivalent.

Texture is a property of the surface of a substance and is both a tactile and a visual three-dimensional quality. Shadows combined with highlights add dimensional illusions to a photograph and assist in rendering these textural qualities. An appropriately placed cast shadow renders texture, reinforces shape, and adds depth to a photograph.

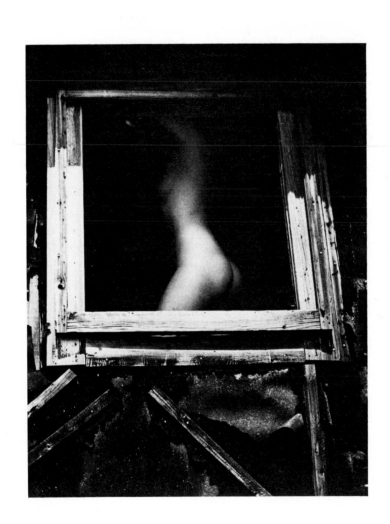

Al Waldhuber (page 16).
Texture is a property of the surface of a substance and is both a tactile and a visual three-dimensional quality, for in fact it can be appreciated by either sight or touch.

(Page 18).
As an example of indirect light, this photograph shows the delicate, soft quality produced by a broad source of illumination.

(Page 19).
Direct light appears hard-edged and somewhat harsh in comparison to the indirect example.

DIRECT OR INDIRECT LIGHT?

Main light forms are categorized as either *direct* or *indirect*. The light quality of each category is referred to as ranging from hard to soft and has distinguishing characteristics which are identified by the effect of the light on the subject and how it renders the various subject planes, the cast shadow, and the texture.

Direct light has a brilliant, hard-edge rendering quality derived from a point source of illumination—or in the case of the sun, a theoretical point source, which is obviously aimed toward the model. Indirect light has a delicate, soft quality coming from a broad source of illumination. Although it appears almost omnidirectional, indirect light has only one source.

DIRECT LIGHT	INDIRECT LIGHT
Hard, crisp quality with rich blacks and clean whites	Soft, delicate quality
Separation of planes that is often dramatic	Subtle grey-tone variation
Easily controlled background separation	Indistinct, soft-edged cast shadow
Distinct, hard-edged cast shadow	Subdued texture
Maximum texture rendering	

ARTIFICIAL LIGHTING

The application of artificial light requires considerable practice and a great deal of sensitivity before it can be used to form a convincing reality. Although it offers the theoretical ultimate in lighting control, beginning photographers usually find themselves quite helpless when faced with simple illumination problems. Unfortunately, too many of the artificial light application faults are a result of overlighting—or just plain using too many light sources on a subject. This is not to imply that multiple-light setups are wrong—just usually unnecessary. Convincing light forms are arrived at simply by applying the minimum of light with logical thought and with the developed ability to "see" light falling on the subject.

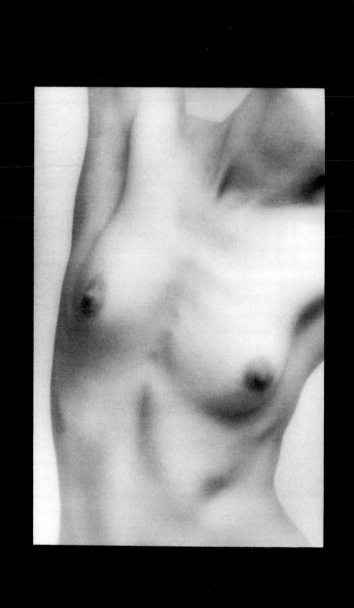

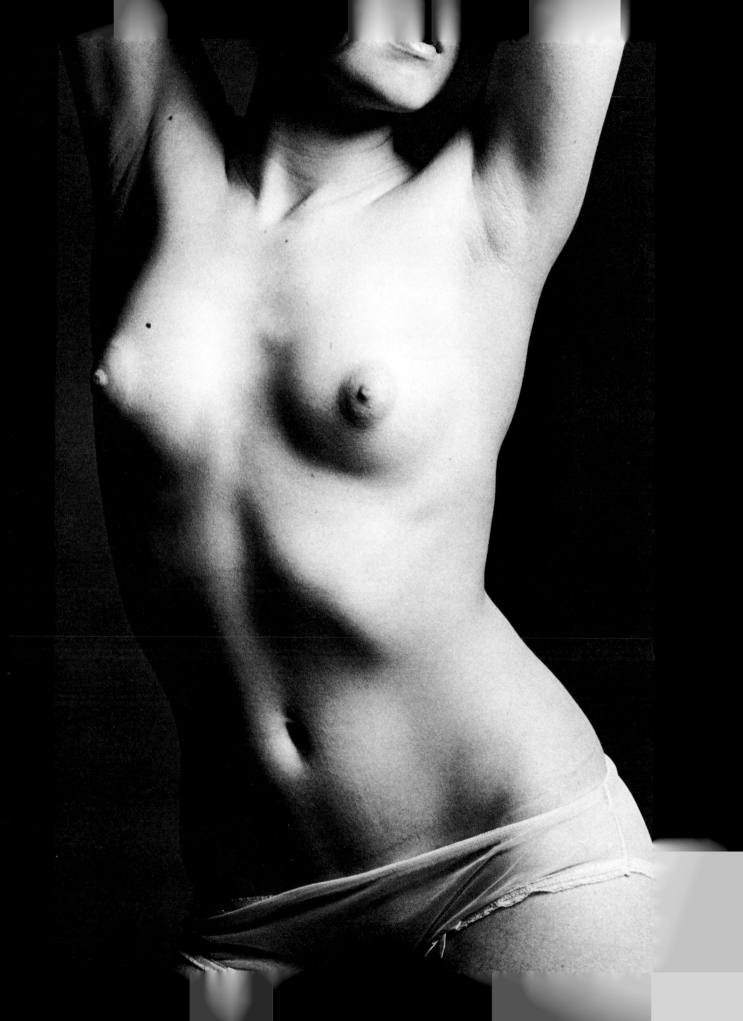

CONTINUOUS ARTIFICIAL LIGHT

There are many sources of continuous artificial light available to the photographer: arc, tungsten, photoflood, and quartz lamps, to name a few. The greatest differences in any of the various lamp types are their color temperature ratings and the quality and quantity of light they emit. Whereas the color of light produced by a source is very important in color photography, with black-and-white materials it is of little concern. Rather, the characteristic qualities and the quantity produced by a source becomes the primary concern.

Very simply, a small source of light will cast sharp shadows and create distinct highlights, while light from a bank of fluorescent tubes, for instance, will give soft shadows and broad highlights.

Most schools and workshops still use the traditional fixed tungsten spots and floods for training students. The point here is that the continuous light source still is the easiest for studying and "seeing" light, while the floods and spots offer the greatest flexibility in light control.

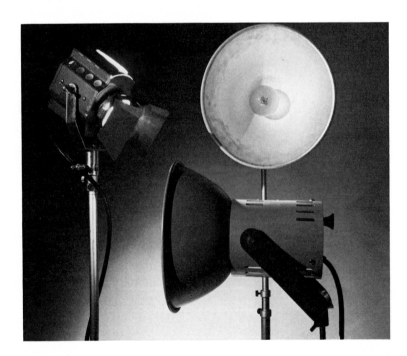

Stephen Frye.
Many types of inexpensive continuous light sources are available. They are a favorite for training, as the light they emit is easy to see and study.

FLOOD OR SPOT?

The typical floodlight has a centrally mounted bulb surrounded by a pan-type reflector that will vary significantly in both size and shape. The degree of diffusion and the area of coverage a floodlight produces is dependent on the size and shape of the reflector. Large, shallow floodlights give off a soft, diffused light and can provide even lighting over large areas.

Hard, directional spotlighting is more useful in exaggerating texture, lighting local areas, creating hard-edged shadows to emphasize subject form, and dramatizing a lighting situation. Spotlights are capable of throwing a concentrated beam of light because the light is focused. A typical spot uses a small bulb with a reflective panlike surface behind it which directs the light through a fresnel lens at the front of the lamp housing. Some spotlights have adjustable light-beam-focusing devices and are marked "spot" and "flood." These markings are only relative and define the direction for more concentrated light, for in fact at any setting the light emitted from a spotlight is both focused and directional.

A spotlight can be bounced from a large surface such as a wall and give roughly the same qualities of light as the floodlight, but with a considerable loss of light intensity or quantity of light.

THE FILL LIGHT

The fill light is used to reduce the overall contrast range between highlights and shadows in a scene that is created by the main light source. Ideal placement may be accomplished by moving the fill light where it will add one unit of light to the highlight side and one unit of light to the shadow side of the model. The fill light must always supplement the main light and should be placed so that it creates no shadows of its own. To check your placement, turn off the main light and look for cast shadows.

Panchromatic film does not record a scene the same as the human eye perceives it. To see more closely what the film will record, learn to view your subjects through narrowly squinted eyes. By squinting at the scene with both the main and fill lights turned on, you should still be able to discern the main light effects on your subject. If the scene still appears to contain unwanted harsh shadows, decrease the distance between the fill light and the model. If all indications of the main light modeling have been washed out, increase the distance.

INVERSE SQUARE LAW

Apropos of direct light, when a lamp is moved to a greater distance from a subject it still gives off the same amount of light, but the light is spread over a greater area. The *inverse square law* relates this light intensity to the distance it must travel and states that the intensity of the illumination falling on a subject is inversely proportional to the square of the lamp-to-subject distance.

In a practical application, if you begin with a light source placed 8 feet from the subject and move the same source to a distance of 4 feet—that is, half the original distance—the light increase will be four times brighter, not twice as bright.

ELECTRONIC FLASH

Unlike any other source of illumination, electronic flash operates on a principle where high-voltage electrical energy is stored in capacitors, then discharged very quickly through a sealed tube of inert gas to produce a short, powerful burst of light. Duration of the burst will range ideally from 1/700 to 1/2000 second, depending upon the capacity of the unit. It is this brief period of light emission which accounts for the most important assets of the electronic flash.

ADVANTAGES OVER CONTINUOUS LIGHT

The first asset, obviously, is speed. The photographer can stop, or nearly stop, even the most rapid action regardless of the slowness of the camera's indicated shutter speed. With focal-plane shutters, the shutter merely provides a point of synchronization, or automatic timing achieved by electrical contacts inside the shutter which close a circuit connected to the flash. This synchronization point is color-coded on most cameras and usually occurs at the marked speed of 1/60 second or longer. Synchronization at any speed is possible with the leaf- or bladed-shutter type because the contacts come together as the shutter blades reach the fully opened position. Consequently, the primary exposure concern is the duration of the flash and not the actual shutter speed setting on the camera. It is this light emission period, and not the opening and closing of the shutter, that actually causes film exposure.

On most focal plane cameras, the electronic flash shutter speed is designated by color-coding, an "X," or a bolt of lightning.

22

Other assets of electronic flash less obvious than its ability to stop motion are its high light output and the fact that it does not generate nearly as much heat as continuous forms of artificial illumination. The high light output can provide unexcelled depth-of-field control, while the lack of intense heat quite simply makes conditions more favorable for photographer and nude model alike.

TYPES OF ELECTRONIC FLASH UNITS

There are electronic flash units available for almost any budget, ranging from the simple on-camera hot-shoe mount to the multiple-light-source studio unit. Between these extreme ranges there are many affordable and functional units on the market. The smallest units have a very low output of light and derive their power directly from the camera, while intermediate sizes usually require an auxilliary battery pack. Large studio units offer the most control of all the electronic flash systems at the greatest initial expense. Usually these sophisticated units consist of a large alternating-current-powered pack that simply stores electricity and distributes it accurately and has a capacity of from one to four flash heads offering tremendous outputs of light. One of the advantages of the studio unit is the ability to add self-contained modeling lights—tungsten or quartz lamps fixed into a position close to the flash tube which accurately allows the photographer to see exactly where the brief flash of light will fall.

One of the most popular units is the portable studio model flash. It combines lightweight portability and cost of the smaller units along with the greater light output and the modeling lamp system of the larger studio models. Rather than a separate power pack, everything is contained in one unit and is operated on an alternating current.

FLASH EXPOSURE

Because electronic flash is not a continuous light form, its exposure cannot be measured by taking a reading with a conventional light meter. There are light meters specifically designed to read the intensity and duration of the flash and convert it directly into *f*-numbers. Many professionals consider them to be essential equipment; however, electronic flash meters often cost considerably more than the average meter type designed to measure continuous light sources.

GUIDE NUMBER. As an alternative, although not as convenient, there is a system which offers an accurate indication of the power of any flash unit without resorting to additional expenditures. This system is based on a figure quoted by the manufacturer for the specific equipment and is known as the *guide number* of the unit.

The guide number is simply the *f*-number required for an exposure multiplied by the flash-to-subject distance measured in feet, for any given film type.

Manufacturers actually calculate guide numbers for various speed films by using their beam-candlepower-seconds (BCPS) rating number and the ASA for the specific film type being used in the following equation:

Guide number = $0.23 \sqrt{BCPS \times ASA}$

For convenience, you may refer to the Guide Number for Electronic Flash chart below for an exposure starting point when using the most common films. Plot the electronic flash manufacturer's rated BCPS output along with film ASA to arrive at an appropriate guide number. This is referred to as a starting point because many manufacturers tend to publish rather optimistic guide numbers for a variety of reasons. And as a matter of professional procedure, you will want to run a simple test to establish a more personalized and predictable guide number.

GUIDE NUMBER FOR ELECTRONIC FLASH CHART

ASA	BCPS OUTPUT OF ELECTRONIC FLASH UNIT				
	500	1000	2000	4000	8000
25	25	35	50	70	100
32	30	40	55	80	115
64	40	55	80	115	165
125	55	80	115	160	230
200	70	100	145	205	290
400	100	145	205	290	410
800	145	205	290	410	580

GUIDE NUMBER TESTING. To perform a guide number test, set up the camera in surroundings typical of the ones in which you expect to be shooting. Make sure the shutter speed is placed at the proper point of synchronization. Accurately establish a light-source-to-subject distance in feet and record it. The subject should contain a full range of tones, or you may include a gray scale in the scene. Take a series of exposures varying the aperture in half-stop increments, that is, *f*/5.6, ½-stop, *f*/8, ½-stop, and so on. Make sure the flash unit has ample time to return to full power between exposures.

Establish a method of determining which frame was shot at which aperture. This could be as simple as remembering the sequence of shooting or actually labeling cards to be included in each frame. Process the film normally and evaluate the exposures according to your usual methods. Evaluation can range from "eyeballing" the highlight and shadow detail to

reading a gray tone on a densitometer. Regardless of the means, select the best exposure. Multiply the *f*-number used to make this negative by the flash-to-subject distance in feet. For example, assume the flash-to-subject distance was 10 feet and the best exposure was *f*/11. Then $10 \times 11 = 110$, your personalized guide number for that particular film. A guide number test must be performed for each combination of lamp, reflector, umbrella, and film sensitivity.

USING THE GUIDE NUMBER. Once you have arrived at the guide number for the lamp in use, divide it by the lamp-to-subject distance in feet, and the result is the working *f*-stop. Assuming the guide number is 110 and the lamp-to-subject distance is 5 feet, then 110 divided by 5 yields *f*/22.

UMBRELLA BOUNCE LIGHTING

Separate guide number tests must be performed to determine the proper exposure for electronic flash light bouncing off an umbrella. Light losses occur both in the umbrella fabric as well as with the increased angle of coverage from a directional light.

 The test is performed in the same way as with a directional light source, that is, the best aperture multiplied by the main-lamp-to-subject distance equals the guide number. Remember, measure the main-lamp-to-subject distance. The main lamp in this case is pointed toward the umbrella and not the subject, so measure from the back of the umbrella to the subject for the proper distance. It is important to always maintain the same distance from the lamp head to the umbrella from one shooting session to the next. The further the lamp head is located from the umbrella, the softer and broader the light source. The closer the lamp head to the umbrella, the more intense and narrower the light source. Keep the distance constant for consistent results.

When using electronic flash bounced from an umbrella, measure the main-light-to-subject distance and divide the guide number of the unit by this distance to obtain the correct working aperature.

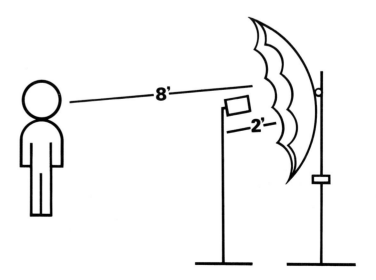

ADVANTAGES. The obvious differences between a directional electronic flash head and an umbrella-bounced head are the very differences found between basic direct and indirect light sources. The quality and the quantity of light are both affected.

When working with a model, some of the advantages of umbrella lighting make it a hard source to resist. The soft, north-light qualities render flattering skin tones that need a minimum of retouching. This advantage alone has caused many studio photographers to work almost exclusively with umbrella-bounced electronic flash.

The large, more even angle of coverage offered by umbrella lighting makes light placement uncomplicated and forgiving. Less critical light placement is excellent for photographers dealing with any moving subject. The wide, even angle of coverage also tends to wrap around the subject and provide a natural falloff of light which reduces the number of lights required to create a particular effect while keeping shadows to a minimum.

DISADVANTAGES. With the advantages of umbrella lighting, what disadvantages could possibly turn you back to using directional light sources? Umbrella lighting is not at all practical where a high degree of contrast is required. Even when using the principle of the closer the light source the more rapid the falloff, umbrella light simply does too fine a job of wrapping around a subject.

When a high degree of light control is required, such as isolating an area with illumination, you will probably opt for a directional light source where you may employ such tools as snoots and barndoors to assist in the isolation. However, an umbrella may still be of assistance as a fill light source for overall contrast reduction.

Due to light losses in the umbrella fabric and light losses that occur from the increased angle of coverage, bounced light sources do not offer much control over extended depth-of-field requirements. That is, to achieve the same amount of depth of field as a direct lamp source, the umbrella source has to be considerably more powerful. Unfortunately, the more powerful the electronic flash unit, the more money is required for its purchase.

UMBRELLA SELECTION. Selection determinations of umbrella are usually based on shape, color, and size. Each variable has its own purpose and advantages as well as disadvantages.

Shape. Two umbrella shapes are available—round and square. Your umbrella selection should be based on personal preference rather than advantages and disadvantages. Both umbrella types offer all of the advantages of the umbrella bounce light. The primary difference is in the specular highlight or catchlight rendering. You will notice that a round highlight is formed in your model's eyes with a round umbrella and a square catchlight is rendered with a square umbrella. Many photographers

prefer the square catchlight because they feel it more closely resembles a reflection from a window. Either form, however, is acceptable.

The round umbrella will wrap light around your model more completely and will keep shadows to a minimum. But because of this wraparound effect, a round umbrella may also have a hotspot. This effect may be used to your advantage, or you may choose to avoid the problem entirely by using the edge of the light source, referred to as *feathering the light*.

The flat umbrella has no chance of a hotspot, but because of this it also cannot provide such a complete wraparound effect as the round umbrella. Many flat umbrellas, however, may be opened completely or closed selectively to widen or narrow the angle of coverage falling on the subject, which makes it a very adaptable light source.

A round umbrella reflector wraps the light around the model and minimizes shadows, but may in the process create a hotspot.

No hotspot is formed by the broad, even light reflected by a flat surface.

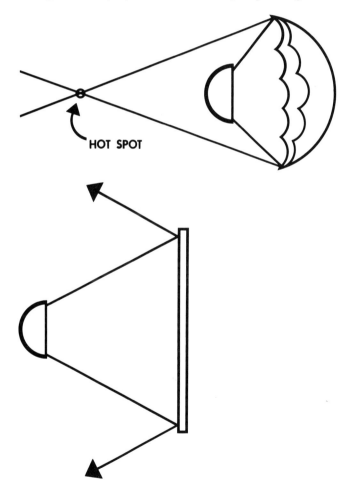

HOT SPOT

Color. Probably the most common umbrella color is a basic soft white. In black-and-white photography, a difference of umbrella color makes only a difference of intensity when the light falls on the subject. A gold umbrella in color photography will warm the subject, but with black and white film it will only record a light-intensity difference.

When a harsh or brilliant umbrella light source is necessary, the silver umbrella is usually selected. Of all umbrellas, silver has the least amount of light loss and most closely approaches a similar guide number to a directional light. Translucent umbrellas are available for shooting through the umbrella surface rather than bouncing off of it. This offers a diffused directional light source rather than a true bounced source. Several manufacturers offer a silver-backed soft white umbrella that allows for soft illumination with the silver qualities of light retention.

Size. The third consideration of size depends primarily on the objectives you have in your photography. A small umbrella takes less light output to produce a greater depth of field and has a smaller angle of illumination. A larger umbrella will require a greater output to produce the same depth of field but yields a softer, broader light that will cover a larger area.

Craig Morey.
Brilliant directional sun provides all the classic qualities of direct light.

DAYLIGHT

Photography was conceived in natural light, and this is still the most common source of illumination today. Because it is natural, daylight is always correct in any of its various forms, it is never monotonous, and the price is most certainly right.

DIRECTIONAL SUN

Directional sun provides all of the classic qualities of direct light—hard-edged modeling, brilliant highlights with deep shadows, and a distinct cast shadow. The angle of the sun is a more important consideration when photographing a nude. The dominant direction of daylight is from above, except for brief periods near sunrise and sunset. A slight variance in the sun's angle appreciably affects the dimensional qualities of the photograph and, most importantly, the proportion of light and shadow in the background. The directly overhead sun creates a background which is illuminated fully and will be rendered with many light tones which may be considered as overlit and objectionable.

An overhead sun casts harsh shadows directly down upon the model, and the eye sockets are encompassed in shadow, rendering a dark band across the eyes similar to a mask. By carefully positioning the model in a morning or afternoon sunlight, background tones may be more easily rendered darker or lighter than the model. Sunlight early or late in the day is more on an oblique angle to the model and will provide a more pleasant lighting form without the often distracting downward cast shadows. Directional sunlight in any form, however, may produce extreme contrast between shadow and highlight areas.

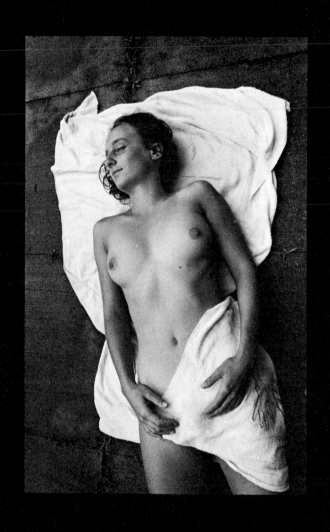

Deborah Stanton (page 30).
When photographing under an overcast sky, shadows are indistinct and modeling appears rather rounded.

Barbara Vance-Halla (page 32).
Watch for unexpected high contrast in subjects photographed under an overcast sky. (Reprinted with permission of the photographer and Penthouse Magazine.)

Barbara Vance-Halla (page 33).
In this example, subject and background choices provide the major contrast within the scene.

Debra P. Romanchak (page 34, left).
A large, dark room will yield high contrast regardless of the window size or shape. In this example, a small horizontal window restricts and concentrates the light.

(Page 34, right).
This photograph was taken in a small, light-colored room. Note how light reflects back to the subject and fills the shadow areas.

(Page 35).
This distance from the model to the window determines the overall lighting effect.

OPEN SHADE/OVERCAST SKY

Natural light always comes from one direction, no matter how subtle, and the direction is usually from above. The qualities of an indirect light source are exemplified by an overcast sky and open shade. Shadows are indistinct and the modeling appears rounded, with the light passing gradually into darker tones. One of the major complaints when shooting inside a shaded area is the lack of contrast. Never take for granted that subjects under diffused light or in shade are always low-contrast. Guard against unexpected high contrast. If a low-contrast condition is the case, however, it may be easily solved by positioning the model just inside the shaded area where reflected light will provide additional illumination and the background will fall off into deeper tone. For additional contrast with either overcast sky or shaded areas, allow the subject and background choices to provide the major contrast within the scene. That is, place a light-skinned model in front of a dark background and a dark-skinned model in front of a light background.

WINDOW LIGHT

Many photographers feel that daylight passing through a window is the most beautiful source of illumination for rendering skin tone. Window light is generally characterized by rendering the figure in one-half highlight and one-half shadow.

Your choice of a window will determine the light reaction on your model and its exact characteristics. The size and position of the window are of primary importance. A large, vertical window will admit more light than a small horizontal window because it has a greater opening to the sky. Likewise, a large, vertical window on an upper floor will admit more light than the same window on a lower floor. A large, vertical window usually admits light from a high angle which falls toward the floor, leaving the darkest area on the ceiling and the most intense area on the lower portion of the room. A small or horizontal window will restrict and concentrate the light. Deeper shadows will appear because with smaller amounts of concentrated light entering the area, there will be less light reflected back to the subject from the room.

The room size and color have as great an impact as the size and shape of the window. The smaller the room and the lighter the color, the more the light from the window will reflect back to the subject. A large room with dark tones will yield a significantly higher contrast regardless of the window size or shape.

The quality of window light can be altered by placing sheer drapes on the window and thus diffusing and spreading the light. This diffusion will reduce the quantity of light hitting the nude but will allow more contrast control with directional sun.

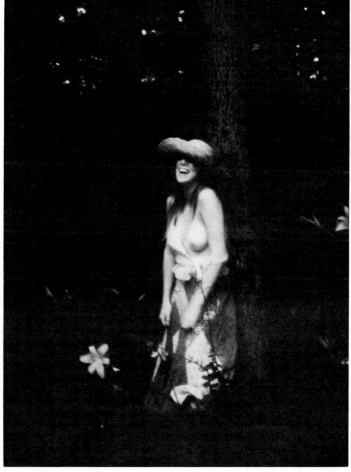

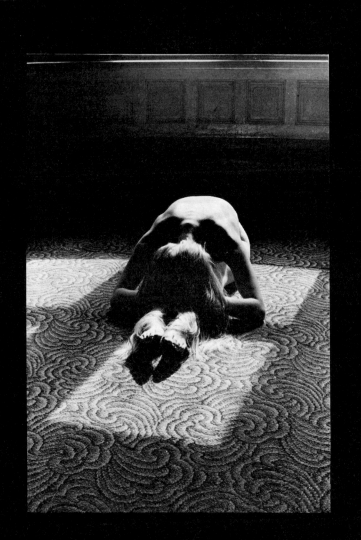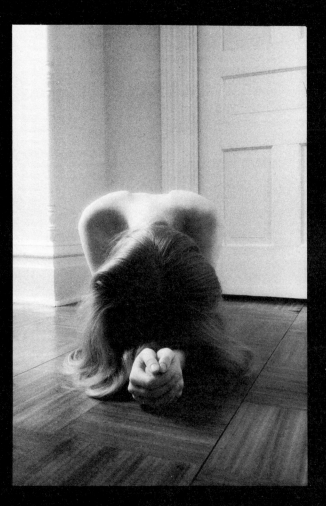

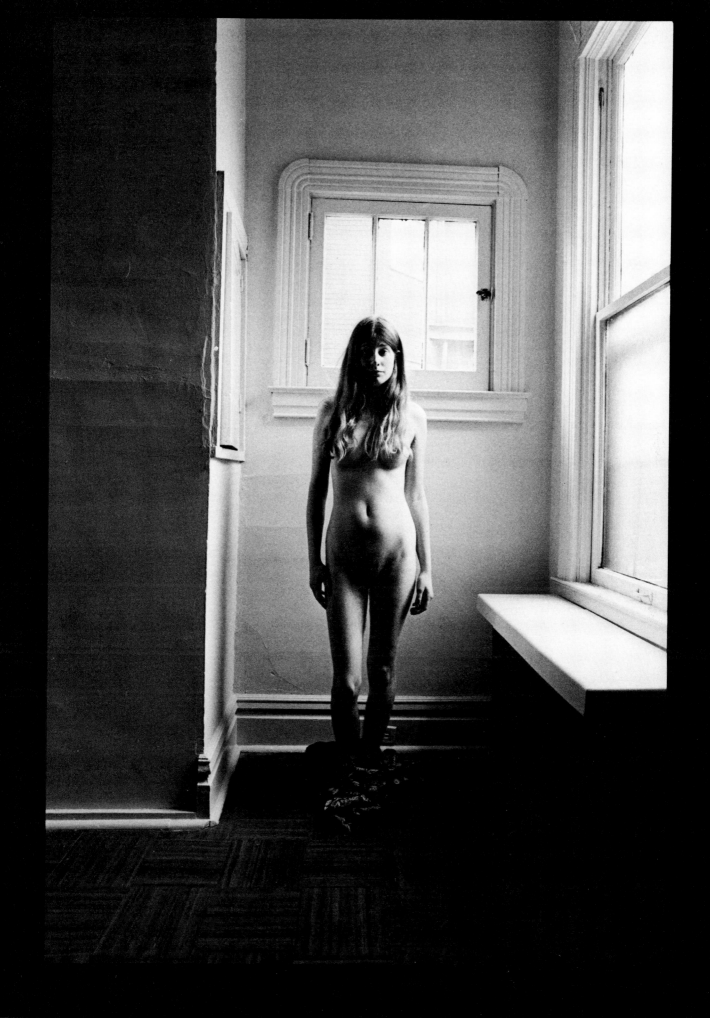

The distance from the model to the window determines the overall lighting effect, and altering the placement by a few feet either way will make considerable differences in the highlight-to-shadow ratio.

The window, as with any source of illumination, is usually not included within the pictorial area so that it does not form a huge, irrelevant highlight and distract from the subject.

CONTRAST CONTROL

The major objection to directional sun photography, as to other forms of directional, undiffused light sources, is the extreme range of contrast. Photographic films are not capable of recording both the highlight texture and the shadow detail in very-high-contrast situations—generally, any scene exceeding a six-stop range between shadow and highlight areas. You will lose control and be forced into exposing for the highlights and losing the shadow details or exposing for the shadows and recording the highlights as blocked-up areas with no texture. One way to exert control is by selecting a camera position which allows either the highlights or the shadow areas to occupy no less than 80 percent of the composition. This way, no more than 20 percent of the overall picture area will be at a loss for detail. This method tends to be rather restrictive, but does solve a problem by working around it.

Without sacrificing compositional selection, there are alternative methods of exercising control over contrast—by providing additional illumination to the shadow area or by altering the exposure and development of the film.

USE OF REFLECTIVE SURFACES

On an elementary level but quite effective, the use of reflective surfaces placed opposite the main light source will bounce light back into the shadow areas of your subject and reduce the overall contrast. If your model can be positioned to take advantage of available reflective surfaces, by all means make the best of the situation. Neutral surfaces such as white walls, concrete, and many natural surfaces such as rocks make excellent sources of fill light. But again, the model must be repositioned in order to fill in all visible shadow areas with found reflectors.

Portable reflectors as simple as a large white mounting board or a more intense aluminum-foil-covered board can provide surprisingly large amounts of fill light when placed opposite the main source of illumination. The boards can be moved so as not to affect the

placement of your model. There are no absolutes involved with the correct angle for placing the reflector other than observing that the angle of incidence equals the angle of reflection.

The amount of fill light is controlled by the reflector surface selected—for example, foil is more reflective than white board—and by the distance between the reflector and the subject. Additional control is afforded by the flexibility of mat board, which allows you to selectively fill the subject by bending the board into either a convex or a concave shape. Incidentally, many commercial firms manufacture protable reflectors in many different surfaces and sizes complete with adjustable stands. The choice is yours.

ELECTRONIC FLASH FILL

Electronic flash used as a fill light source allows you an easy method of controlling the range between highlights and shadows. This method of contrast control provides additional illumination to the shadow areas and thereby lowers the overall contrast range of the scene. Many photographers feel that filling the shadows with electronic flash is a difficult procedure and should be left strictly to the professionals. Nothing could be further from the truth.

STEP 1: SUNLIGHT EXPOSURE. Since you cannot control the intensity of the sun, you will have to work with the exposure it offers. Do not allow the shadow areas to influence your light reading too heavily, since they will be raised in tonal value by the fill light that you will add to the scene. Rather, take a meter reading from the dominant skin tone area. (For applications other than nude photography, where a skin tone may not be present, an incident light meter reading, underexposed one stop, is adequate.)

If you are using a focal-plane shutter, remember that you cannot use a shutter speed faster than the X-synchronization point.

Example: Sunlight exposure 1/60 at *f*/16

STEP 2: HOW MUCH FILL? In determining the amount of fill light you want to fall on your subject, there are several generalizations you may start with. In color photography, a one-stop difference between the main and the fill light is considered to be ideal. With black-and-white materials, two stops' difference is considered to be normal. The differences between the intensity of the main and the fill lights are referred to as the *lighting ratio* of the scene. Using black-and-white film and referring to the sunlight exposure example of 1/60 at *f*/16 for the main light, a two-stop difference would be *f*/8. This means you must place enough light on the subject from the flash unit to require a lens setting of *f*/8. Although your actual shooting exposure

will remain 1/60 at *f*/16, shadows will be recorded with two stops less exposure relative to the rest of the picture.

STEP 3: PLACE THE FILL LIGHT. Electronic flash fill light placement in a synchronized sunlight application follows the guidelines for any fill light placement. Always remember that there must be only one main light and one set of cast shadows. The electronic flash head should be placed where it will allow one unit of light to fall on the highlight area and one unit of light on the shadow area. It should never be allowed to create cast shadows of its own.

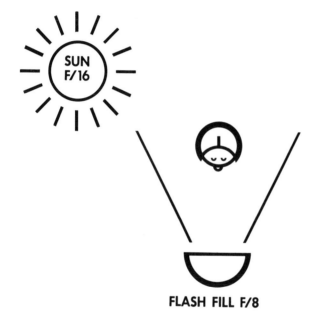

FLASH FILL F/8

Although your actual shooting exposure will be at f/16, the fill light must be placed so as to require a lens setting of f/8. Shadows will be recorded with two stops less exposure relative to the rest of the picture.

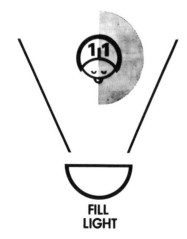

FILL LIGHT

When applying electronic flash fill, the flash head should be placed where it will allow one unit of light to fall on the highlight area and one unit of light on the shadow area.

◇ The distance from the flash unit to the subject determines the amount of light falling on the subject and consequently the amount of fill light present in your exposure.

◇ The calculator dial on the back of the flash unit will show the distance the flash must be placed relative to your subject for the proper exposure at various *f*-stops.

◇ Find the *f*-stop on the dial that represents the flash illumination level you want. Then read the distance required for the exposure opposite that *f*-stop.

◇ Place your flash head at this distance and make the required sunlight exposure.

The f/8 distance with ASA 100 film would be approximately 7 feet.

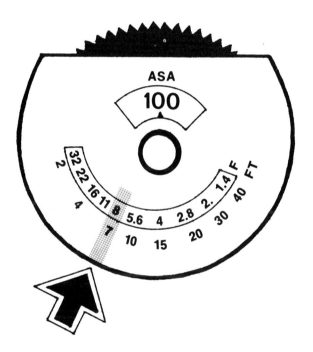

You will run into many instances where the indicated distance is greater than your selected camera distance. At this point, you have two choices. Either (1) take the flash off the camera position and move it to the required distance or (2) reduce the power of the flash unit until it conforms to the proper exposure. This is where the more sophisticated variable-power flash units are extremely handy. By simply switching the power to a lower rating, you can avoid taking the flash off the camera. But with a little experimentation, you can determine how much light is blocked by placing a single layer of a white tissue over the flash head, or two layers, and so on.

ALTERING FILM PROCEDURES

In photographing scenes in which the range of shadows to highlights exceeds the limitation of the film and there is no chance to illuminate the shadows by reflectors or electronic flash synchronized with the sunlight, alteration of the negative exposure and development may be the only solution.

To control the normal values in subjects of excessive contrast, an empirical but effective rule is to overexpose the film in the camera and underdevelop the negative in the darkroom. If the neutral tones of a scene are overexposed by one stop on the exposure scale, accompanied by a 25 percent reduction of the normal time, a negative with a more normal contrast range will result.

ELECTRONIC FLASH
TO ADD CONTRAST

ELECTRONIC FLASH AS MAIN LIGHT

On a flat, overcast day the electronic flash unit can be used as a main source of illumination and provide modeling to your nude that would be otherwise unobtainable. Instead of using the sun as the main light source and the electronic flash as the fill, their roles will be reversed; however, the procedures in determining exposure will remain almost identical as flash fill.

STEP 1: DAYLIGHT EXPOSURE. Even on an overcast day, you still cannot regulate the sun, and every procedure you apply must account for the exposure it offers.

Example: Sunlight exposure 1/60 at *f*/8

STEP 2: MAIN LIGHT PLACEMENT. Since the electronic flash unit will be playing the role of a main light source, you will want it removed from the camera position so that it will render a light form with direction rather than merely illuminate the model from a frontal, fill light position. Basic main light placement rules (pp. 42-44) should be observed for positioning the flash head on the subject.

In this case, where the electronic flash unit provides the main light, the natural light exposure should be less than the electronic flash light. That is, primary exposure is based on the flash rather than the sun.

STEP 3: DETERMINING EXPOSURE. Applying the same rules as with fill flash, the lighting ratio you will want to begin with is for the ideal black-and-white contrast range, or the main light two stops more intense than the fill light.

In the example, *f*/8 was the indicated aperture for a daylight exposure. Two stops more exposure, or *f*/16, will provide the proper exposure for the flash unit used as a main light. Set the proper *f*-stop on your camera for the flash exposure and check the calculator dial on the back of the unit to find the distance required for that *f*-stop to provide adequate exposure.

Example: The *f*/16 distance with ASA 100 film would be approximately 4 feet.

Place your flash unit at this distance and make the required electronic flash exposure. This exposure will allow the daylight to fall two stops under the main light source and will provide an excellent fill source.

ELECTRONIC FLASH SYNCHRONIZED WITH TWILIGHT

With synchro-twilight photography, exposure is based on the *f*-stop controlling the electronic flash unit and the shutter speed controlling the ambient light exposure. The ideal is to produce an optimum exposure for both the twilight sky and the nude model being illuminated by the flash.

When distances of open space occur between the subject and the background, a somewhat surrealistic effect is achieved. That is, the flash will properly expose the nude and then illumination will fall off rapidly, allowing the middle ground to be rendered very dark or underexposed. The sky, however, will appear as any normally exposed twilight shot.

STEP 1: ELECTRONIC FLASH READING. Set the flash reading as for any normal exposure using either the calculator dial on the back of the unit or the guide number procedures as previously outlined.

STEP 2: AMBIENT LIGHT READING. Remember that when you are using a focal-plane shutter with electronic flash, you can select a shutter speed slower than but never greater than the X-synchronization point. Take an ambient light meter reading, but keep the proper *f*-stop that controls the electronic flash exposure constant. That is, if the proper flash exposure indicates *f*/11, take an ambient light reading looking for the shutter speed that correlates with *f*/11. The shutter speed may be 1/60, 1/30, 1/15, or longer. Again, remember the *f*-stop controls the flash exposure and the shutter speed provides a point of flash synchronization and controls the ambient light exposure.

SOME STUDIO EXAMPLES

The photographer's ability to "see" and record light can make the difference between a drab nude study and one that lives—conveying the personality of the photographer as well as projecting his or her competency. The more you know and understand about light, the greater is your ability to use that light to achieve the effect you want.

As with the many directions in photography, there are no absolute rights or wrongs, just different ways of approaching any given situation. The following information and illustrations represent one person's approach. These examples are not intended to lock the nude photographer into forms of light that must be rigidly followed; rather they should act as guides to be used for studying light as it falls on the human form. These are, for the most part, basic lighting methods. Consider them as stepping-off points for your own innovations.

BORROWING FROM PORTRAITURE

What would the nude photographer have in common with the portrait photographer? Certainly not the head-and-shoulder shots gracing the pages of high school yearbooks. Light—the universal language among photographers—is the common ground that has been most fully explored with the human head by the portraitist. In many cases, allowing the nude model's facial details to fall entirely into shadow offers a more timeless approach. That is to say, when a face is totally identifiable, most viewers are impulsed to react to a "picture of Jane" rather than a universal image of a female form. As a nude photographer you will find that many occasions will arise when a normally rendered head shot or partially rendered head shot is appropriate and should be included in the final image. There is no conflict here. Evaluate and absorb what the portrait photographer offers, and learn to apply the appropriate knowledge at the proper time.

SIX PORTRAIT LIGHT FORMS

The placement of the main source of illumination is used as the basis of classification for the six most commonly accepted portrait light forms: *butterfly, loop, broad, short, split,* and *skid.* Each light form, in this order, produces increasingly more shadow area on the facial planes.

BUTTERFLY LIGHTING. The main light is placed directly in front of the face and casts a symmetrical nose shadow directly beneath the nose resembling a

butterfly in flight. Butterfly lighting is used most successfully to deemphasize facial texture and was considered to be the glamour lighting of the 1950s.

LOOP LIGHTING. The main light is moved slightly from the front of the face so as to cast a loop shadow down from and to the side of the nose. Overall modeling effects are increased from butterfly lighting, especially on the shadow-side jaw line.

Each light form in the order indicated produces increasingly more shadow area on the facial planes. The upper *figure on the right illustrates forms most universally applied to the female face, while light forms shown in the lower figure are predominately used on males.*

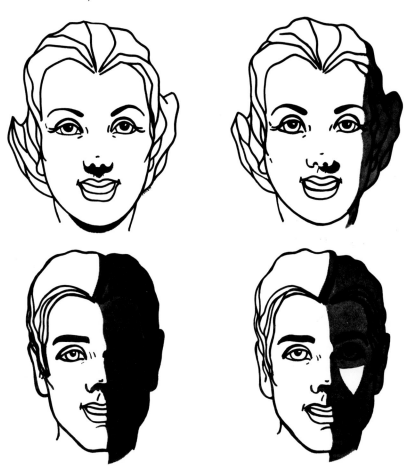

BROAD LIGHTING. The main light fully illuminates the side of the face turned toward the camera. The shadow-side cheek is characterized by a triangular patch of highlight. This light form is used primarily to help widen thin or narrow faces.

SHORT LIGHTING. The main light fully illuminates the side of the face turned away from the camera. The shadow or near side of the face is also characterized by a triangular patch of highlight on the cheek plane. Short lighting is a dramatized light form that emphasizes facial modeling and helps narrow a full face.

SPLIT LIGHTING. The main light is placed to the side and renders half of the face in complete highlight and the other half in complete shadow. Split lighting is a variation of broad and short lighting without the triangular patch of highlight.

SKID LIGHTING. The main light is placed in a high three-quarter rear position and skids off of and renders highlights on dominant facial planes only. This light form provides maximum emphasis of facial contours by skimming light across high contours and allowing low contours to be rendered in shadow.

A single light source illuminates the figure from a three-quarter frontal position. Shadows are softened naturally when using a light-colored background.

BASIC LIGHTING EXAMPLES

Sources of illumination can vary on any of the lighting examples in this section. For instance, a directional or bounced light source may be used, ranging from tungsten bulbs to electronic flash. The basic principles will all remain the same; however, the quantity and quality of the light may vary greatly. Each different source will provide a variety of effects and should be carefully considered as to which will best serve your objectives.

SINGLE LIGHT SOURCE

THREE-QUARTER FRONTAL. In nude photography it is important to retain modeling in the figure so that a strong three-dimensional effect is maintained. One way to achieve this is to permit the light to come only from one side or the other. By placing the main light in a three-quarter frontal position, delicate shadow areas appear on the figure that define the form. Shadows are softened naturally when using a light-colored background; therefore, the need for a fill light to reduce contrast is eliminated.

A single light source with a dark background can offer a dramatic low-key effect which allows you to isolate body parts by illuminating only the essential elements. With the model surrounded by dark tones, you may find it necessary to add a reflective fill source so that the model may be adequately separated from the background. A simple white mounting board may provide sufficient illumination.

AXIS LIGHT. A curved surface under axis lighting reflects the maximum light from the area nearest the light source with the intensity diminishing as the surface curves away. At the edge of the curve, the outline will appear quite dark and will separate easily from a similar tone of background or will

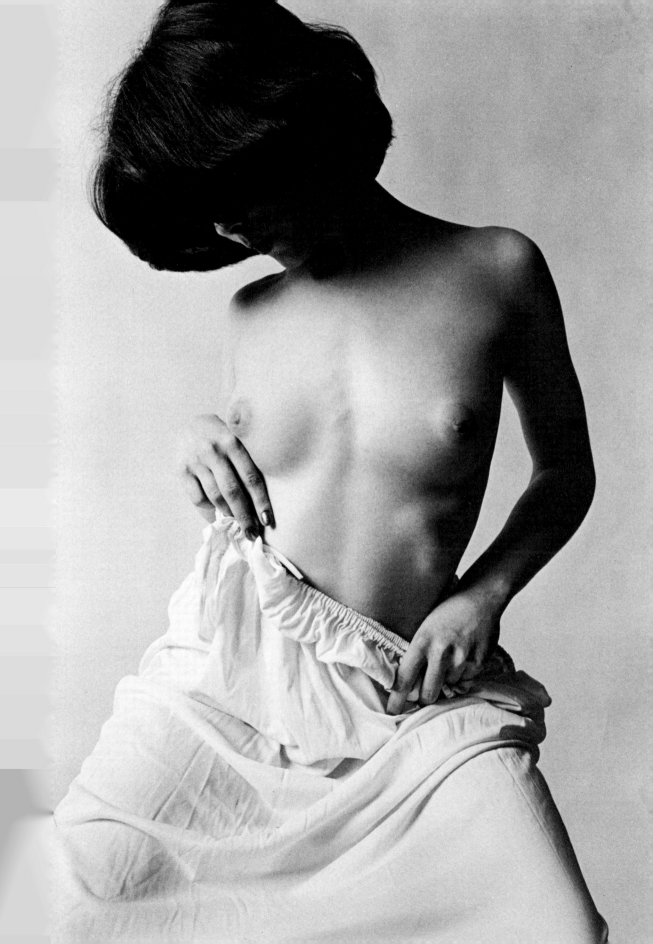

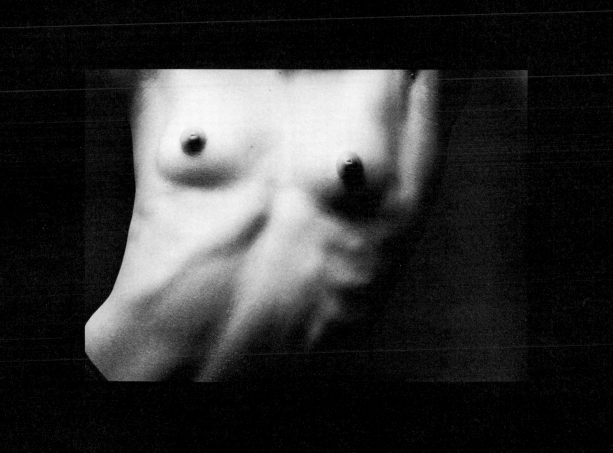

*This dramatic low-key effect is
achieved by using a single light source
against a dark-toned background.
Delicate shadows define form.*

*A single light source is shown in a
three-quarter frontal position with a
reflector card opposite it to provide
separation between the model and the
background.*

blend in with a darker tone of background. With axis lighting, form is
defined by subtle variations within fully illuminated areas rather than by the
play of light between dramatized highlights and shadows.

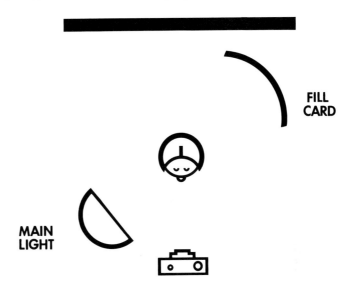

ADDING A BACKGROUND LIGHT

The background should be treated as a subject. Light it independently. If
the final image is to retain the same background tone that you visually
observe, the background must receive the same amount of illumination
as the nude. For example, if the main light is 4 feet from the figure,
a light of equal intensity must be placed 4 feet from, and turned
toward, the background.

*If the final image is to retain the same
background tone that you visually
observe, the background must receive
the same amount of illumination as
the nude.*

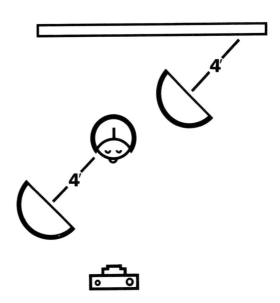

A single light source directed on the background—always located opposite the main light—increases separation between the model and the background. The background light should never be placed on the same side as the main light, as the results will not correlate with the natural effects of the sun.

REFLECTED BACKGROUND LIGHTING

Reflected background lighting as a main source of illumination offers the greatest degree of latitude both in actual lighting and general rendering techniques. The model may be shown as a full silhouette or as a delicately printed high-key image, depending on the degree of fill light. Loss of resolution, excessive grain, and other photographic "flaws" can be associated with this lighting technique, but because these effects are anticipated they may be used to your advantage.

Place two lights at 45-degree angles toward the background. Ensure that this background illumination is even throughout the pictorial area. Place the model in front of the background, just far forward enough where no light hits the figure directly. A full silhouette of the model is all that should be seen. Fill cards or other reflective surfaces may be placed to the right, left, or in front of the model. All or any combination of these fill sources duplicate various natural light conditions. The background brightness should be four times that of the frontal fill cards.

To minimize the problems of excessive flare, black scrims may be located just out of the camera range to shield stray light from the camera lens.

Samuel J. Gentile.
A light source directed on the background increases separation between the model and the background.

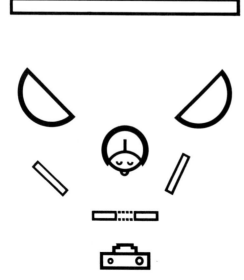

Two lights are placed at 45-degree angles to the background and bounce the main illumination to reflective surfaces which softly illuminate the model.

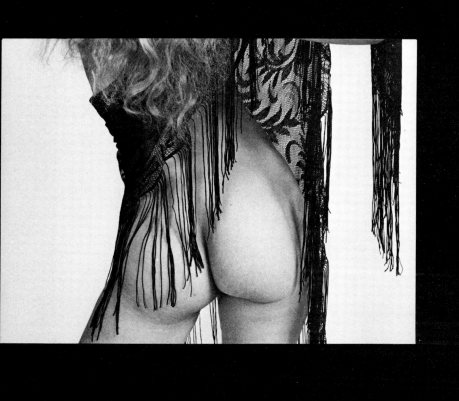

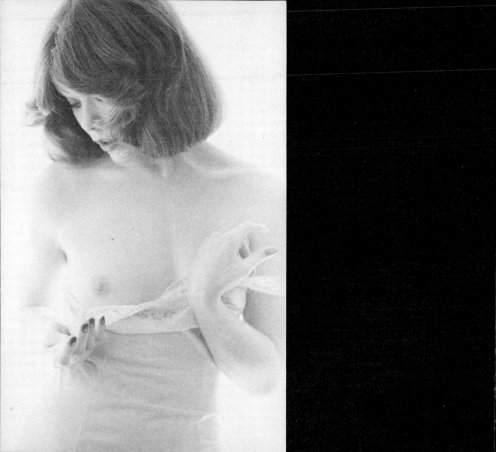

This is an example of reflected background lighting. Loss of resolution and grain as a result of a background brightness four times the intensity of the frontal reflectors plus delicate high-key printing create this photographic effect.

When you evaluate the results from this type of lighting situation, do not expect "normal"-appearing negatives. Primary tones are high-key—especially with a blond caucasian model—and the resulting negatives will appear to be overexposed, sometimes to the point of looking opaque. Do not be too rash in your evaluation. Even if the negative is truly overexposed, attempt a print and be pleasantly surprised at your results. This type of negative can be printed on almost any grade of printing paper with results varying from harsh grainy effect to soft, subtle gray tones.

CROSS-LIGHTING

Starting with the model at least 6 feet from a dark-toned background, place one light to each side of the model, one a little closer to the figure than the other. Notice the strong modeling created through the play of highlights against shadows.

As a variation on this same idea, move the two cross-lights further to the rear of, and pointed toward, the model for added separation from the background. Supplement this main source with a frontal fill light to reduce the extreme contrast range and to render subtle shadow detail in the figure. Black scrims should be placed to block extraneous light from the rear cross-lights to shield the camera lens from flare.

Place one light to each side of the model, one closer to the figure than the other. This positioning defines one dominant source of light.

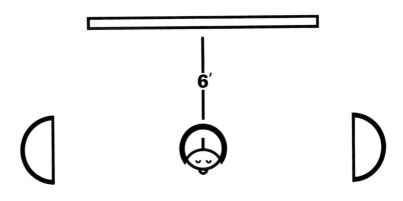

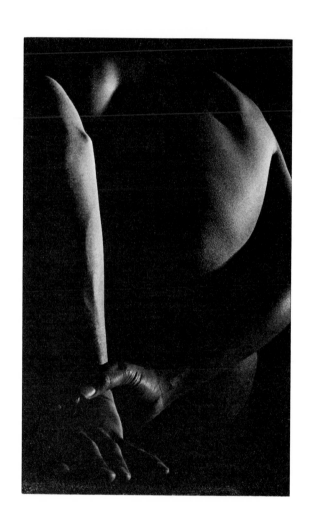

In this example of cross-lighting, the male nude was positioned 6 feet from a dark background.

DIFFUSED MAIN LIGHT

One way the effect of broad window light can be artificially duplicated is by using a large diffuser in front of the main light source. Place a large, white, seamless background paper from the floor to the ceiling in a three-quarter frontal position to the nude. A suitable substitute for the seamless paper, such as a sheet or a shower curtain, may be used. Place studio lights behind the paper and observe the broad, even distribution of light it provides. When the light passes through the diffuser and reaches the model, it is diffused such that the contrast range is extremely low and no additional lights are needed to create a soft effect between the highlights and the shadows.

A large diffuser in front of the main light source will produce illumination such that the contrast range is low and often needs no additional light to fill in shadows.

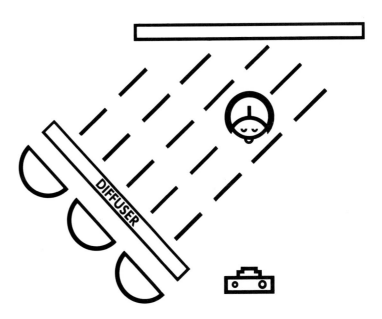

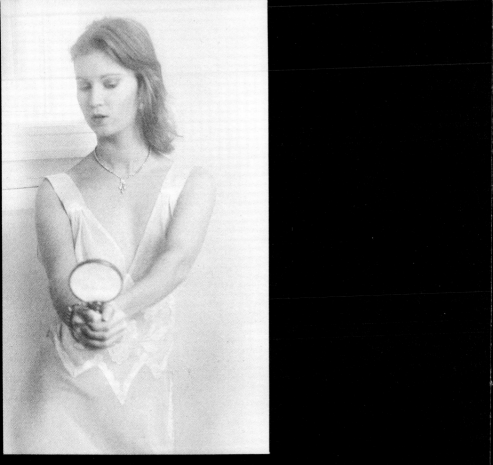

The illumination in this photograph was achieved by placing two tungsten lights behind a sheet of translucent plastic.

SUMMARY

The contemporary nude photographer's creative tools are numerous, but the most pliable of all is lighting. As you compare photographs and diagrams, note that lighting is the means of creating form in and defining the contours of the figure. As you have observed, exciting photographs can be created with just one light or with a complete multiple-lighting setup. The single most basic principle to remember and understand about studio lighting is that, regardless of the number of lights, there should be only one dominant light source, with all other lights completely secondary to it. Study the photographs and methods in this section and throughout the book. Accept or reject them as ideas for your own use as you see fit, and use them as a springboard for your own original concepts in lighting.

As an alternative to cropping L's, a piece of cardboard with a section the size of a negative removed aids in isolating an individual image on a contact sheet.

TECHNIQUES

I had created a particularly fine photograph several years back, and as photographers tend to do, I looked for a little praise. Off I went to one of my writer friends with my freshly mounted photograph and asked for a first impression.

"All right!" he exclaimed, "that's a sharp photo. What kind of lens did you use? It must have been expensive." His excitement over mere technical competence rather than aesthetic appreciation deadened my enthusiasm immediately. I needed to make a point—loud and clear.

You see, I have always been of the firm belief that equipment does not make the photographer, or the photograph. I will admit that sophisticated gear can make a job much easier and the results technically more perfect. But the aesthetics have, and will, rest in the mind of the photographer.

The ideal recorder of Bresson's "decisive moment" or of Stern's disciplined imagery does not rest in a black box obtrusively held in the photographer's hand.

Force the masters to handle an Instamatic and I will guarantee their imagery will not turn from excellent to mediocre. Besides, don't we all agree that the ideal camera would be built into the human eye and documentation would occur with a simple wink?

When new students come to me, inevitably their first question is, "What camera and how many lenses do I need?" Most look with shocked disbelief when I reply, "A fully adjustable camera with a normal lens."

Now a statement like that leaves the field wide open . . . from the seventy-cent Diana 120 with aperture, shutter speed, and distance adjustments (complete with color-corrected plastic lens and neck strap) to the supersophisticated multi-hundred-dollar 35mm SLRs.

To prove my point, my six-year-old daughter and I stopped at a local flea market (noted for its selection of cameras) and after a half-hour of searching we found two used Diana cameras with the incredible pricetag of twenty-five cents each. Off to a store to purchase two rolls of Verichrome-Pan 120 film at fifty-seven cents a roll. That is a grand total of a dollar-sixty-four—plus tax on the film. We had enough equipment for two people—under two bucks.

After five minutes of instruction and five minutes of shooting without film, I gave my daughter her first assignment . . . an editorial portrait.

The next week, I gave the same assignment to my students. You guessed it. The print from my six-year-old was on the critique board and met with many favorable comments. I will admit, a comparison between a six-year-old's vision and a twenty-plus-year-old's imagery is not a fair evaluation.

After all, the six-year-old sees with a fresh eye—and thus has the advantage. Everything is a new experience. The child has not yet

learned, or been conditioned, to take so much for granted. Everything is new and thereby seen for what it is.

Yes, all of us past ten years of age are at a definite disadvantage. We are preoccupied with the considerable technicalities of photography—worrying about sharpness, exposure, and processing. We can be corrupted until we reach a state where we no longer really look at the things around us. A Nikon or Canon with six lenses does not make us photographers. Nor does a plastic Diana with one lens and strap. An outstanding photographer is made by retaining an ability to look freshly at subjects and situations.

So I waited for my writer friend (the same one who had so aptly critiqued my work earlier) to publish another article. I read it and rushed over to his office. Full of enthusiasm, I proclaimed, "I read your article . . . it is tremendous. You must have used a good typewriter to write it. Was it expensive?"

My point was made.

EQUIPMENT

From your initial exposure to the final print presentation, photography is a continual loss process. The human eye, connected to the brain as it is, has the often incredible ability to assume detail and clarity that do not really exist. Each step away from your initial vision has progressively less latitude and affords you absolutely no leeway to assume anything.

The act of recording the nude on film takes all of the assumption out of the creative act. In many cases, what you actually see is also lost simply because the film does not have the latitude of the eye. And to the photographer's distress, printing paper has even less latitude.

And what can you, the photographer, do about this situation? Learn your equipment and materials. Learn to deal with these limitations and, most importantly, to create within them.

CAMERA SELECTION

If it feels right, use it. No better advice can be given for camera selection. One or another prestigious brand of camera makes little difference in any photographer's vision. The test of a true photographer is whether he or she uses all available tools to their maximum.

Camera *format* selection, however, does have a significant bearing on the photographer's vision. Different working methods required of the various formats can change an entire approach to subjects as animate as the nude. Most photographers prefer the ease, convenience,

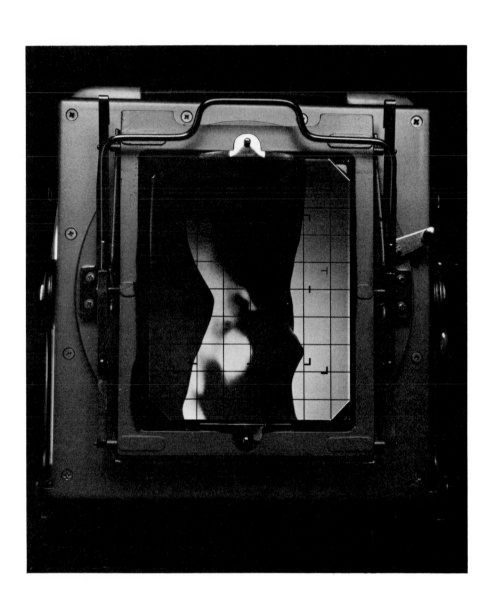

and mobility of a lightweight hand-held camera; however, Edward Weston brought a new realm to the art of nude photography by the use of a large-format view camera.

Hand-held cameras do obviously free the photographer of cumbersome equipment and encourage visual exploration and quantities of exposures. Large-format cameras, on the other hand, force a more methodical approach, and the user tends to study the subject more thoroughly. Whatever your choice, become thoroughly familiar with it. Equipment familiarity breeds predictability.

FOCAL LENGTHS

Different focal lengths directly alter your vision and your final results; therefore, knowledge of the spatial relationships achieved by using various lenses is important. Nude photography, unlike many other areas of photography, offers no set rules governing the selection of focal lengths; however, there are certain optical facts that remain universal to all subject matter.

From the same camera position, lenses of different focal lengths change the size of the subject in the image—that is all they do. It is incorrect, however, to say that focal length has no effect on perspective. Even though the relative sizes of near and far objects remain identical with lenses of different focal lengths, the angle of view and overall image sizes will be different and can create different impressions in the photographs.

Three-dimensional space is represented by two dimensions in a photograph. Because of this it is easy to deceive the viewer by showing false impressions of the actual scene photographed with unusually long- or short-focal-length lenses and forcing the audience to view your prints from "incorrect" viewing distances. When your photograph is viewed from a shorter-than-correct viewing distance, the scene appears to be flat; when it is viewed from a greater-than-correct distance, it appears to have strong perspective. Because of this, nudes photographed with a telephoto lens usually appear to be flat, while nudes shot with a wide-angle lens usually appear to have exaggerated perspective. Objects appear to decrease rapidly in size with the distance from the camera when strong perspective is employed; with flat perspective, objects appear to decrease slowly in size with their distance from the camera.

Marian Goldman from the photo series "Under the Skirt" (page 62). Nudes photographed with a wide-angle lens appear in an exaggerated perspective, as in this example.

(Page 64).
A typical effect from a fog filter placed in front of a lens. Filter effects are more noticeable when using larger aperatures.

Wayne A. Persing (page 65). This romantic nude was produced with a diffusion filter and a steamy bathroom mirror.

CAMERA POSITIONING

A number of factors influence the positioning of the camera in relation to the nude. The first factor, obviously, depends on the amount of the human form you plan to include in the photograph. For normal perspective rendering with head and shoulder shots, place the lens axis at the height of the model's lip and tip of the nose. For waist-up shooting, lower the camera until the center of the lens is level with the breastbone. For full-figure shooting, lower the camera position again, until it is level with the navel.

The most important factor affecting the choice of camera positioning is the manner in which you want to render the nude. For instance, by lowering the camera position from the normal axis for a full-figure photograph and tilting the lens upward, the legs will appear elongated while full shoulders will appear considerably narrower. By raising the camera position and tilting the lens downward, small shoulders can appear to be broader.

Beginning photographers tend to adjust the distance between the camera and the subject in order to achieve the desired image size, or alternatively to select a convenient location for the camera without giving consideration to the perspective. With continual shooting, you should learn to control perspective to obtain the desired effect. The camera position should then be selected on the basis of desired perspective, and finally the focal-length lens should be used that will produce the appropriate image size.

FILTERS

Photographic filters for black-and-white photography fall into two major categories, those used for effects and those used for contrast. Filter makeup ranges from a pure glass with the color added in the molten stage to sheets of gelatin. Pure glass filters are extremely expensive, while the pure gelatin filters are easily damaged. The most common types of filters found in photographic stores are a combination of these two extremes. Although they may appear to be colored glass, the average filter is a composite of sheet gelatin sandwiched between two layers of glass and firmly adhered with cement. This makes this filter type considerably less expensive than molten colored glass and much more durable than gelatin filters.

Gelatin in itself is easily damaged. It will dissolve when placed in contact with water and fade when exposed to bright light sources, and any contact with its surface will cause a permanent defect. Sandwiching gelatin between glass assists in preserving it, but certain precautions still must be exercised. Moisture in contact with composite filters will loosen the cement bond and eventually affect the gelatin. Also, the glass does little to slow the process of fading the gelatin. Store and maintain your filters as you would any piece of photographic equipment.

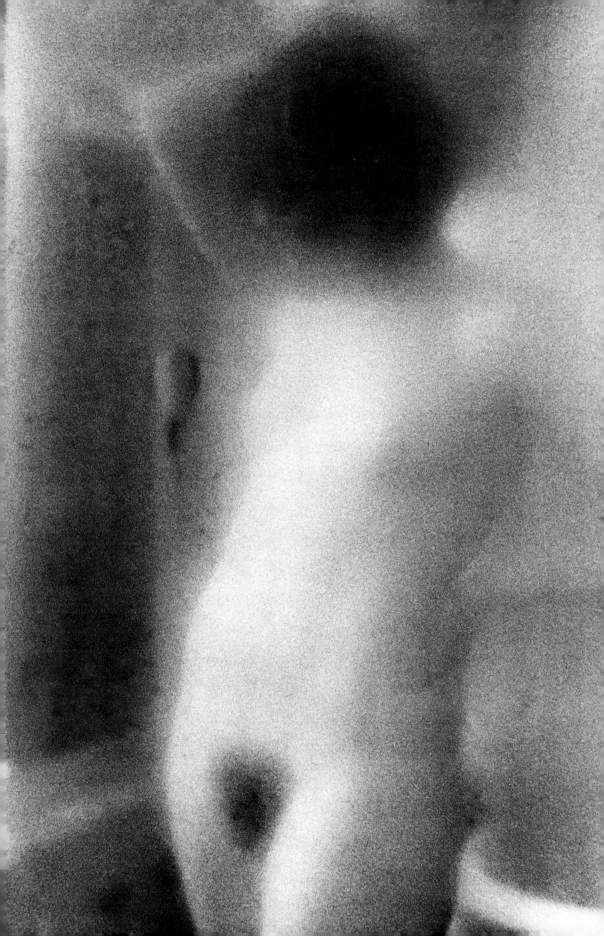

EFFECTS FILTERS.　　Effects filters can produce anything from multiple images to the illusion of fog on a sunny day. Typical special-effects filters include the cross-star, fog, diffusion, split-image, and multiple-image filters. These filters are readily available and advertised heavily. Many times their uses are quite appropriate; however, regulate your use of them and do not fall into the gimmick filter trap.

CONTRAST FILTERS.　　Contrast filters are the main concern of this section. Knowledge and proper use of them can assist you in controlling the overall contrast and, most importantly, the tonal separation of your black-and-white photographs. In color photography, colors separate themselves from each other. In black-and-white photography, however, all colors are reduced to tones ranging from black, through the intermediate grays, to white. Many colors, although noticeably different to the eye, record as equal tones when recorded on black-and-white materials. The classic example is a red rose against a green leaf which all reduces to one shade of grey when recorded in black and white.

The principle involved when using contrast filters in front of the camera lens is that a filter will lighten its own color and darken its color complement. But in use, the lightening and darkening effects actually go beyond this simple statement.

Red, green, and blue light added together form white light and are known collectively as the *additive primary colors*. By subtracting any one of these colors from white light, a *subtractive primary* or *color complement* is formed:

◇　The elimination of red forms cyan.
◇　The elimination of green forms magenta.
◇　The elimination of blue forms yellow.

Remembering that a filter lightens itself and darkens its complement makes it easy to memorize these complements to recall a filter reaction to tone. A little word association may assist for the G–M, R–C, and B–Y combinations. For example, the complement of green is *m*agenta and is easily associated with *G*eneral *M*otors or, for sports car enthusiasts, *MG*.

Back to the complementary rule, a filter actually lightens its own color *and* colors adjusted to it on the color wheel and darkens all others. If a red filter is placed in front of the lens, for instance, red, yellow and magenta are lightened while blue, cyan, and green are darkened.

FILTER EXPOSURE COMPENSATION.　　Additional exposure compensation is usually required when using any colored filter, for such a filter blocks a portion of the light that would normally hit the film. Exposure compensation is referred to in terms of a *times factor*, such as a 2× or

(Top).Red, green, and blue light added together form white light and are known as the additive primary colors.

(Center). By subtracting any of the additive colors–in this example, blue–a subtrative primary, or color complement, is formed.

(Bottom). A filter lightens its own color and color adjacent to it on the color wheel and darkens all others.

one-stop exposure increase required. When you are using a filter with an in-camera meter, exposure compensation is automatic. However, this is not the case when you are using electronic flash, as your in-camera meter is not applicable.

Filter factors are based on the exposure principle that there is a 2× factor between every adjacent setting regardless of whether the settings are shutter speeds or apertures (see the figure below).

Michael Lewis Ketter.
Use of a red 25A filter can render a dramatic sky, as in this outside application. In the studio, this filter is used to wash out skin pigment and to increase contrast.

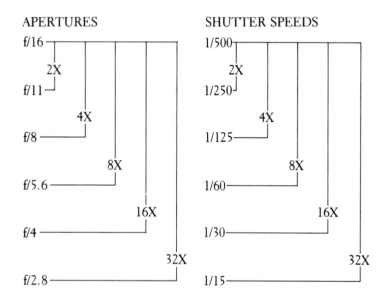

As the filter factor increases, so does the contrast; that is, the greater the times factor, the greater the contrast.

THREE COMMON CONTRAST FILTER TYPES

MEDIUM YELLOW (K-2). This has a 2× filter factor and lightens yellow, red, and green while it darkens blue, magenta, and cyan. Its major effect on skin tone is a slight increase in overall contrast along with a general lightening effect.

LIGHT GREEN (X-1). This has a 4× filter factor or a two-stop exposure increase. Since it darkens red, magenta, and blue, you can anticipate that it will render a model's skin tone considerably darker while it increases contrast significantly.

RED (25A). This has an 8× filter factor or a three-stop exposure increase. Use of the red filter will provide greatly increased contrast and will noticeably lighten the model's skin tone. Red lipstick, for instance, will record as a very light shade of gray.

These three filters are considered to be standard, and they provide an excellent starting point for filter experimentation. Each filter gradually increases the overall contrast while progressively requiring one additional stop of exposure increase.

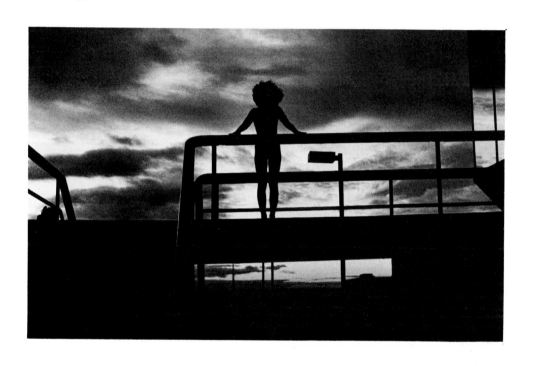

FILM SELECTION

Film preference and selection lies closely allied to camera selection. Many photographers swear by the results of Tri-X or a comparably fast film and boast of 16x20 grain-free prints. Others feel they must use a low-speed–high-resolution film for even the most modest of enlargements.

Careful procedures and refined techniques are what are most important. The amount of exposure any negative receives has a definite effect on its resolving power and grain size. Highest quality is obtained by minimum exposure—that is, the least amount of exposure that will render the desired shadow detail. The slightest degree of overexposure is disastrous to resolution and overall negative quality.

What is commonly referred to as *grain* on an enlargement is actually the clumping of many grains of silver. The more grains which form a clump and the greater the distance between clumps, the lower the resolution of the negative.

The ASA rating of any film allows for a wide margin of safety. Using the film manufacturer's rating will usually result in more exposure than necessary for optimum results. Actual film speeds depend largely on characteristics of your camera shutter, exposure meter, exposure methods, developer type, and processing techniques. With so many variables in the way of your optimum negative, it is suggested that you perform individual tests to determine minimum densities. A few tests and plenty of camera experience with any one film type will produce consistent negative quality. Thoroughly explore and familiarize yourself with one film type before jumping to others.

THE FIRST SHOOTING SESSION

At first thought, it seems virtually impossible to prepare for an unknown photographic experience such as the first time you are preparing for a nude shooting session. In a workshop situation, the instructor will no doubt furnish you with a list of materials relative to the assignment. But thinking practically, there are certain things that should be accomplished prior to any shooting session.

As a starting point, you should get the purely mechanical and mundane out of your way so that you are free to concentrate on the subject in front of your camera.

◇ Plenty of film should be available and handy to load in your camera. Film is one of the cheapest commodities in photography. Always have

more film available than you expect to use. Nothing is more frustrating than running out of film during a stimulating shooting session. Even the slightest break in momentum can change a supersession into a "When are we going to be done?" mood.

◇ If you plan on using more than one focal length of lens, your auxilliary lenses should be readily available to mount quickly onto your camera. This means they should be within arm's reach and with front and rear caps removed.

◇ Tripods, cable releases, PC cords, and exposure meters should be readily available.

◇ Location preparedness is imperative. If you plan on a studio-type session, have lights plugged in and tested, seamless backdrop in position, and exposures predetermined as much as possible. When shooting in the environment, be prepared with a location and at least one alternate. Imagine your plight after finding a remote location and upon your return with model and gear finding a Boy Scout picnic in progress.

SELECTIVE ELIMINATION

For a first-time shooting suggestion, begin by selectively eliminating or simplifying as much as possible. In any case, do not start out with all full-figure shooting unless you are prepared for some pretty disappointing results. With the full human figure in front of your lens, there are many parts to pay particular attention to—arms, legs, torso, head, hair flow, to name a few. In an environmental location, add 5 million blades of grass, 4800 trees. . . . In all fairness to yourself and your model, begin with simple compositions and force yourself to control these situations. As you gain control and confidence, gradually add more of the body and the environment.

In first shooting sessions, the use of a moderately-wide-angle lens (35mm) is strongly suggested. With the idea of tightly controlled compositions, this lens type will force you to move in closely for isolation. This closeness forces a working relationship with the model that quickly eliminates all uneasy feelings between the model and the behind-the-camera-hiding photographer. Forcing tightly controlled compositions also eliminates the chances of having to resort to poses that fall into the nude cliché categories. Trite poses are usually a result of "What else is left to do?"

DIPLOMACY

As a photographer, you have a number of things to be concerned with during a shooting session—all the technical considerations associated with

equipment, light, and the image. With so many things to think about, it is easy to forget that it is a difficult job to work in front of a camera, especially with your clothes off. And it is work. If you think otherwise, pose for just fifteen minutes.

Outside of basic human respect, a little diplomacy goes a long way during a shooting session. One of the things that makes anyone in front of a camera totally uncomfortable is knowing that the photographer is displeased with the session for whatever reason. To make the session more pleasant for both you and the model:

◇ Keep a conversation going even if it is a bit one-sided.
◇ Avoid excessive criticism.
◇ Keep shooting.

Psychologically, it is better to keep up a regular shooting pace. Long delays without taking pictures imply that the photographer has not seen anything which is visually exciting enough to record. The hand-held camera format allows film to be used, which in turn allows for visual exploration and refinements. If the shooting session begins slightly on the tense side, an ongoing conversation and regular picture taking should loosen you both up.

THE RIGHT TO PRIVACY

The right to privacy is simply the right to live free from unwanted or unnecessary publicity or interference which would injure a person's feelings or present the person in a false light before the public. Pertaining to you as a photographer, the right to privacy prohibits any use of a recognizable picture without the individual's written consent.

Subject matter as sensitive as photographs of the human figure is left wide open to legal interpretation—often on a local level and based on the reaction of the "ordinary" citizen. With this in mind, when you are photographing a model in a recognizable manner, obtain a signed release from the individual. It makes absolutely no difference whether the model is in full consent during the photo session, you must still obtain written consent. An appropriate model release form is available from most photographic stores.

PROCESSING TECHNIQUES

Assuming that you have reached a correct exposure, processing of the negative will now determine your overall success. Clumping of the silver grains significantly reduces the film resolution and results in more "grain" appearing on the final print. Such clumping cannot be avoided; however, it can be minimized. To reduce clumping and its consequent results:

◇ Control all solution temperatures.
◇ Eliminate an acid stop bath.
◇ Exercise good agitation procedures.
◇ Reduce film wet time.

SOLUTION TEMPERATURES

If a negative is moved from a cool to a warm solution, it will expand. Move it from a warm to a cool solution and it will contract. Any expansion and contraction of the emulsion allows grain movement and increases chances of clumping. It is important to keep all solution temperatures constant.

ACID STOP BATH

For a developer to react properly, it must be slightly alkaline. The stop bath is obviously acid. Mix the two together and they neutralize each other, releasing gases which will damage the delicate emulsion, especially on slow-speed, thin-emulsion films. It is suggested that the stop bath procedure be replaced by a plain water rinse.

AGITATION PROCEDURES

Too little attention is usually paid to agitation. Film gelatin is like a sponge that soaks up developer, and unless agitation occurs, developer agents in the exposed areas become exhausted. Agitation is necessary to move fresh chemistry to the surface of the film. The overall rate of development and the evenness of the developer action are influenced by agitation procedures. Lack of agitation produces underdevelopment and unevenly processed negatives, while continuous agitation produces overdevelopment and uneven processing.

FILM WET TIME

The longer the film remains wet, the longer the emulsion is swollen, and consequently more grain clumping can occur. To reduce wet time, use a relatively fast developer, use rapid fix followed by a hypo eliminator, and a minimum wash time. Place the film in a wetting agent and carefully wipe excess water from the surface. Many methods may be employed to wipe film, and every professional has his or her own preference. Whatever way you choose, remember that the film is delicate and so great care should be taken to avoid scratches.

PRINTING

Whether you use variable-contrast or graded paper in a conventional pulp or the resin-coated surface are all incidental matters. Your main concern must be the control of your chosen materials. Optimum print results occur with methodical procedures.

Make print test strips that reflect the total range of the print scale. Include a deep shadow area and a highlight area. Evaluate the test strip for highlights that remain brilliant yet have detail and texture. Then check the shadow areas for richness of tone. If shadows appear muddy and gray, choose a higher-contrast grade of paper. If shadows are rich black but lose all traces of shadow separation, choose a lower grade of paper.

The "ideal" print from a full-range negative will contain a maximum paper black, a long intermediate range of gray tones, and a clean paper white.

As an aid in printing rich tones, expose a small piece of printing paper to white light and process it fully. Process another piece of paper that has received no exposure and set them both aside. When you are ready to evaluate a print, compare the black patch to the richest black on the print and the white to the cleanest white on the print. If your print does not contain at least a small amount of both tones, select another contrast-grade printing paper or adjust exposure time until it more closely matches.

CONTACT SHEETS

One of the most valuable learning tools in photography is a good, readable contact sheet. Printing criteria here are the same as for any good photographic print. A properly produced contact sheet can offer you a history of the success or failure of a shooting session and should never be

carelessly knocked out. The poorer the quality of the contact sheet, the more difficult it will be to evaluate.

The value of a good contact sheet extends past the obvious use of selecting the best-suited images for enlargements. They can be used to assess:

◇ Tonal qualities of the images
◇ Lighting and composition
◇ Reasons for unsuccessful images
◇ Directions for future shootings

It is important to study the images that just do not make it as well as the more successful images. Regardless of what you have heard, there is nothing sacred about contact sheets. Do not hesitate to mark all over the images if it helps in your process of evaluation. They are expendible and can easily be made again. Study your mistakes so that you will not repeat them.

Evaluating contact sheets stimulates your thought process—you are forced to think about what you have shot. Thinking, in turn, generates new ideas and approaches.

As an aside, you may find that making cardboard cropping L's and using them to isolate the individual frames on the contact sheet will be of tremendous assistance in your evaluation. Use of the L's will allow you to concentrate on each individual image without distraction from the other images.

AFTER THE SHOOTING SESSION

After a shooting session, one of the most critical aspects to be concerned with is the time lag between picture taking and film processing. This has nothing to do with the technical aspects of the latent image. Rather, your own "freshness of approach" is at stake. That is to say, the amount of enthusiasm retained for a shooting session is inversely proportional to the time delay prior to processing and printing. As a follow-through, contact-print your negatives as soon after the processing as possible. Do not make the mistake of attempting to shortcut and bypass the contact stage, for this is a critical process—critical because it permits another area for your vision to take charge, both technically and aesthetically.

In most cases, the height of photography is in the initial vision behind the camera. With many photographers, all acts following the

exposure are anticlimactical. A natural excitement follows through to the contact print stage from the shooting if it is accomplished within a reasonable period of time. It is imperative to process and contact-print one shooting session before entering another session. The process of learning photography is based on building knowledge. What is learned in one session is logically carried into future sessions.

SPOTTING AND ETCHING

It should go without saying that any defects on the surface of the print are to be corrected before a print is considered finished and ready for presentation. Light-colored spots, usually the result of dust on the negative at the printing stage, may be touched up by any number of methods ranging from pencil to Spotone dyes.

A fine-point watercolor brush, such as a #1, is adequate for the application of dyes. Since the photograph is made up of a granular structure, you should in effect replace the grain. That is, spot on the dye rather than paint it on. The secrets to a good spotting technique are:

◇ A fine-tipped brush
◇ The brush kept relatively dry
◇ Developing a light touch
◇ Moving around the print rather than concentrating in one area
◇ Above all else, patience

A little more difficult to handle are the occasional unintentional black marks which appear on the final print. These result from any number of faults; however, light-blocking particles of dirt that fall

Use of a relatively dry brush applied with a light touch is essential in print spotting.

Considerable practice is required to master print-etching techniques. Use of a #15 disposable surgeon's scalpel is recommended.

on the film prior to exposure in the camera is the most common culprit. Scratches and pinholes account for a large share also. Two procedures are recommended for their removal: either the use of a commercially available chemical reducer or print etching with a knife.

Personal preferences dictate the type of etching tools, but it is said that a good print etcher can perform equally well with a broken soda bottle or a sophisticated etching knife. A #15 disposable surgeon's scalpel is recommended for the best results.

Very small black spots can be lifted by placing the point of the blade in the center and pricking them out. But for larger areas, the idea is to gradually shave off shades of gray rather than to dig into the emulsion of the print. If you carry etching too far—that is, make the black

area too light—you can spot the tone back in. If, however, you dig well into the emulsion of the print, get another print and begin again.

Surface defects that have been retouched may show up rather boldly in oblique light. Areas that have been spotted are raised above the print surface, while etched areas are below. To balance them, a photographically safe spray is suggested to create a new, even surface. Before you make a purchase, read the product label and make sure the spray is safe for photographs.

Any of these finishing procedures requires practice and is not mastered immediately. Attention to even the smallest details will pay off in your overall craftsmanship and presentation.

PRINT MOUNTING

Besides giving a finished appearance to a photograph, mounting can assist in protecting your work. An unmounted photograph can easily be wrinkled, dented, or creased. By adhering your print to a substantial support such as mounting board, there is less susceptibility to these forms of damage. Window overmats provide further protection by offering a surface slightly higher than the print. This is especially beneficial when you intend to frame your work. Photographs can adhere to glass when any degree of moisture is present in the air. If you are using a window overmat, this problem is eliminated, as the mat will come into contact with the glass rather than the photograph.

A print mounted on a mat board of larger size appears to be more finished than a print mounted with all the borders trimmed away (bleed mounting). One reason for this finished appearance is that the mount board border provides a neutral zone between the print and the environment in which it is displayed.

Although the best way to determine a mount board size is to lay the print against a variety of board sizes and visually determine the size best suited to the image, there are some commonly accepted combinations that are time-tested:

PRINT SIZE	MOUNT SIZE
11x14	16x20
8x10	14x17
5x7	11x14
Smaller	8x10

Mount color selection is largely a matter of personal taste. Again, however, time-tested procedures indicate that black-and-white prints look best mounted on variations of white. A warm-tone print is best served on a warm-tone mat such as a cream. Cold-tone prints are best on cold white, leaning slightly toward gray.

Use of rich black and brilliant white mat boards are discouraged as they distract from the black and white tones of the print and in comparison make the print appear too gray.

DRY MOUNTING

The following section on dry mounting is directed toward those of you that have or may have access to dry-mounting equipment. These procedures are geared strictly for the use of this specific equipment. Although you may hear of those who use a common household iron, remember that anything other than the proper equipment is not good enough. At the very least, make-shift equipment such as the iron is extremely unpredictable and cannot offer the even pressure exerted by the dry-mount press. Uneven pressure during the heat stage may cause blistering, warping, and buckling of your print.

There are no substitutes for the proper dry-mounting equipment. Even distribution of pressure and temperature is guaranteed when using a dry-mount press.

To begin dry mounting you need the following: a dry-mount press and a tacking iron, one mount board per print, a cover board as large as or larger than the largest mount board, dry-mount tissue, mat knife, pencil, straightedge, ruler, a clean work area with a cutting surface (discarded mount board), and finally, the prints to be mounted. While assembling the proper materials, allow the dry-mount press to come up to temperature. The ideal temperature, for conventional and resin-coated papers alike, ranges from 185° to 220°F. Consult the tissue manufacturer's specific recommendations, as different types vary greatly in their requirements.

All surfaces that are to be used in the dry-mount operation, except the dry-mount tissue, should be thoroughly freed of moisture by preheating in the dry-mount press. Both the mount board that

the print will be mounted on and a cover board of the same size or larger should be preheated for at least one minute. Remove the boards and allow them to cool.

Place the print between these two boards and place in the press for thirty seconds. This added measure not only eliminates moisture from the print, but it also flattens the print and makes the job of final trimming much easier. After the thirty seconds, remove the print and boards from the press and allow them to cool.

Take a sheet of conventional dry-mounting tissue to the back of the print, starting at the center and pulling the tacking iron toward the print corners. Do not exert an inordinate amount of pressure on the tacking iron as the heat—not physical force—must be allowed to melt the tissue. Pressure from the tacking iron can severely crease the print. Make sure that during this tacking process the tissue is held perfectly flat against the print, as buckling of the tissue will show as wrinkles once the print is mounted.

After you are sure that the tissue is firmly attached to the back, proceed to trim the excess dry-mounting tissue and/or the print borders away from the print. Arrange the print on the mounting board, following the methods previously outlined for print placement, and finally tack two opposite corners of the tissue to the mount board. Place the cover board (preheated) on top of the print to form a sandwich—mount board, tissue, print, and cover board. Insert the sandwich into the dry-mount press for thirty seconds, remove, and allow the freshly mounted print to cool on a flat surface for approximately five minutes. After inspection, if you find that the print is not firmly attached to the board, replace the print in the dry-mount press and repeat the final operation as often as necessary.

A SHORTCUT. A current trend with photographers is to print on a paper size larger than the actual image, for instance, a 6x9 print on an 11x14 piece of printing paper. The larger printing paper thus includes the borders of the smaller image—or more directly, offers an immediate appearance of having been mounted. A photograph printed in this method can then be mounted on the same-size mounting board, thereby eliminating the tedious positioning and trimming stages of a conventionally presented print.

COUNTERMOUNTED PRINTS. Another current trend that has the obvious advantage of being lightweight—great for print mailing—offers ease of storage, and permanence of the mounting surface is the method of countermounting. Countermounting is quite simply dry-mounting the final print back-to-back with a piece of fully fixed and washed printing paper of the same size and type as the print. It is essential that the same type of printing paper be used for both the print and the countermount so that the two emulsions will pull evenly against each other and the print will therefore lay flat. Unmatched papers will pull unevenly against each other and warp.

As long as the countermounting paper is given the same care and attention as the actual print paper, your mounting surface will be as permanent as the print. Countermounting with printing paper provides the purest mounting surface of all mounts and is even more acid-free than the best museum-quality 100 percent rag board.

CUTTING A WINDOW MAT

In preparing to cut a window mat, assemble the following: a sturdy work table and cardboard to be used as a cutting surface, the mat board for the window mat, a Dexter mat knife with fresh blades, a ruler, straightedge, pencil, and finally, a photographic print.

STEP 1: MEASURING. Measure the print to be matted, allowing approximately ⅛″ loss on all dimensions. Transfer these measurements to the reverse side of the board that will be used as the window mat. Allow your pencil lines to extend beyond the corners of the area to be cut out.

STEP 2: PREPARATION. On a sturdy work table, tape a piece of mat board firmly in place to be used as a cutting surface. This will serve two purposes: the mat board surface will protect the table top and will keep the mat knife blade from dulling so quickly. Care must be taken to replace the cutting surface frequently, as grooves from previous cuts will cause the mat knife blade to waver severely. Adjust the Dexter knife blade for the proper depth so that it just penetrates the surface of the window mat. The more the blade extends beyond this point, the harder the mat knife will be to control, as the added depth will cut deeper into the cutting surface as well as the window mat and will increase drag.

STEP 3: CUTTING. Always work with the mat knife on the inside of your guide lines. Penetrate the knife blade through the mat in the lower left-hand corner approximately ¹/₁₆″ outside of the actual area to be removed. This overcutting allows for the beveled knife blade to penetrate corners and eliminates ragged corner cuts. Once the blade is securely imbedded in the board, place the straightedge against the knife and ensure the straightedge is parallel to the pencil guidelines. Push the mat knife gently forward until you have overcut the guideline corner by approximately ¹/₁₆″, as you did at the start of the line. Remove the knife and reposition the window mat board where the blade can be reinserted at the lower left-hand corner of the second guideline. Continue cutting, rotating in a clockwise direction, until all four sides are cut. Ideally, you should be able to pick up the mat board and the window cutout will drop out. If your corner overcuts were not long enough, however, turn the window mat over and carefully cut away the corners with a razor. If overcuts were too severe, burnish them with a blunt instrument until they seem to merge into the mounting board.

STEP 4: MOUNTING THE PRINT. Several options are available for adhering the print in alignment with the window mat:

◇ The print may have been previously dry-mounted to another board. In this case, align the window mat on top and tape-hinge the two boards together.
◇ Tape the print to a backing board and align the window mat on top. Again, tape-hinge the two boards together.
◇ Tape the print directly to the back of the window mat. It is still suggested to tape-hinge a backing board to the mat to ensure against damage to the print.

These last two methods of attaching the print to a window mat may serve as an alternative for those of you without access to the proper dry-mounting facilities.

WET MOUNTING

With wet mounting, the washed print is positioned on a support such as masonite while it is still wet. As the print dries, the photographic paper shrinks and actually laminates itself to the mounting surface. Although not a commonly used procedure, wet mounting does provide a sturdy support, especially for extremely large prints. Once the photograph is mounted in this manner, it may be easily cut with a saw and provides an especially useful technique for three-dimensional presentations such as a photographic cube or a multilevel bas relief hanging.

To proceed with wet mounting, prepare the following materials: a smooth board such as masonite, sandpaper, white glue, and a print to be mounted.

STEP 1: BOARD PREPARATION. Cut a sheet of masonite or other smooth-surfaced board slightly smaller than the anticipated print size. Lightly sandpaper the entire surface to provide a "tooth" for the print to adhere to, paying special attention to the outer edges of the board.

STEP 2: PRINT PREPARATION. Prepare a print by taking it through all normal processing steps, including the final wash. Do not dry. If the print you plan on mounting is already dry, immerse it in water for approximately ten minutes or until it is totally pliable.

STEP 3: APPLYING GLUE. While the print is still soaking in water, saturate the sanded surface of the masonite with white glue diluted with water. The glue must be spread evenly and thinly over the entire surface. Spreading may be done with a brush; however, the hand is preferred, as lumps or dirt particles may easily be detected with the fingertips.

STEP 4: APPLYING PRINT. Wipe the excess water from both sides of the print and carefully place the print on the glue-covered board. With a dampened cloth, press the print onto the board, working from the center outward to the edges. Although you must smooth the print over the board, work carefully, as the print emulsion is still wet and very delicate. After you are sure that the print is applied smoothly, wipe any excess glue from the print surface with a clean, damp cloth.

STEP 5: DRYING. It is best to place the mounted print on blocks to dry. Placing it on 2″ boards, for instance, will allow the air to circulate from both sides and will accelerate drying. Once the mounted print has thoroughly air-dried, the surface will form an extremely tight bond with the wood mount. Excess print edges will curl upward and need to be trimmed. Sandpapering with a sanding block quickly removes excess print edges and leaves a clean, slightly beveled edge on your finished print.

GUIDANCE AND CRITICISM

Expert guidance and constructive criticism offered by an instructor or other photographer is comforting. Unfortunately, few have this constant luxury and must depend upon personal judgments or upon the reaction of others—who may or may not have an appreciation of the hours laboriously spent on the final print. As photographers, we all have the tendency to look at our work with an overview of the entire process, evaluating the means as studiously as the end result. In the general audience's collective eye, however, a nude image stands on its own. Unless it is obviously poor, there is little or no concern with technique. And rightfully so.

A PHOTOGRAPH MUST COMMUNICATE

Photo by R. Valentine Atkinson.

With all the words devoted to photographic technique, it is easy to forget that ultimately a photograph is nothing more than another form of visual communication. As such, it should communicate to any one—not just to other artists. This is not to say that you must continually strive to please everyone, or that you may have to work under a number of compromises, but rather that your photograph has to communicate. It is admitted that a capacity for aesthetic enjoyment of any art form is necessary for any criticism and that this capacity is increased and developed by observing and thinking about the various aspects of any subject matter.

After analyzing a great many photographs, the photographer can usually attribute his or her successes to two primary factors: a print must first gain the viewer's attention, and secondly, it must evoke an appropriate reaction. Totally bizarre or gimmicky work may easily gain the attention and evoke the reactions—but not necessarily the reactions that are intended or even desired. On the other hand, photographic nude clichés and boring remakes of the totally familiar do not even gain the viewer's attention. A successful nude photograph needs a blend of several elements.

FAMILIARITY AND SURPRISE

First of all, in any work of art, familiarity is a necessary element to convey to the viewer. A nude in a recognizable form offers a certain amount of reassurance and orientation. Since the reassurance of the familiar is so closely allied to the boredom of the inevitable, a successful piece of art needs an element of surprise. Surprise should be highly prized, for no matter however gently, life can be enriched if a photograph can remind us not to take the world for granted. The photographer's ability to record common subjects and yet introduce an element of surprise allows the viewer to recognize the work as a rediscovery of the familiar. A successful nude photograph should explore the aesthetics of surprise and sensual pleasure. (The term *sensual pleasure* is used here as opposed to the grosser emotion of just plain astonishment.)

GAINING ATTENTION

Gaining the viewer's attention is achieved by content, technique, visual structure, or any combination of these elements. Without at least one of these, the print will be left unnoticed. A nude photograph usually has enough inherent content to gain attention. The ideal technique is the unnoticed technique. That leaves us with visual structure, the subject of the next chapter.

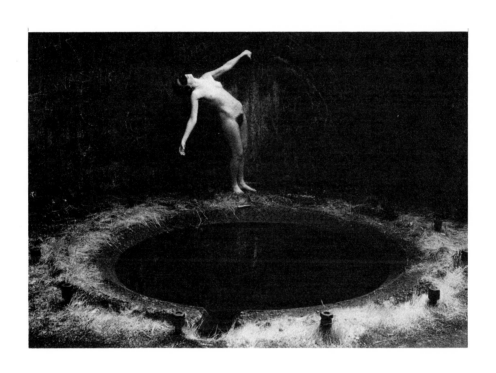

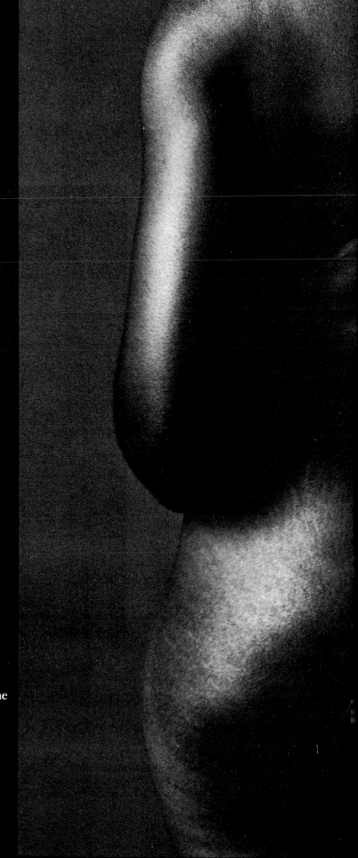

Marta Gray.
Line in a photograph is usually abstract and most often describes the
juxtaposition of two tones, as in this powerful illustration.

VISUAL
ELEMENTS

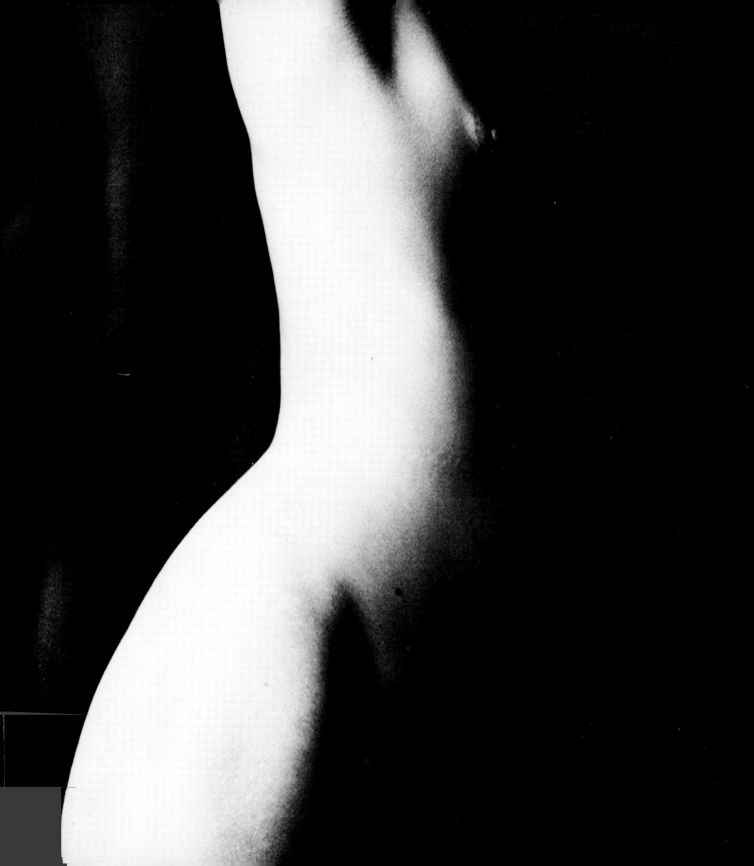

For every student of photography who spends years in courses called Design and Composition, Visual Structure, Design Trends, and a host of similar titles, there are almost as many instructors prefacing these courses with an apology—an apology and a further explanation that the subject matter they are about to teach cannot be taught. Good composition cannot be taught, you see, because like all creative efforts, it is a matter of personal development and growth. But the courses continue to be scheduled and students continue to enroll.

VISUAL STRUCTURE

Photographers usually seem to be too preoccupied with mechanical techniques such as exposure and processing, and so often the imagery seems to be taken for granted. The shooting experience, the actual moment the shutter is depressed, is the climactic point of the entire photographic process. Yet so much time is occupied with the technical talks of before and after the climax.

Maybe all of those apologetic instructors have a point: they in fact cannot teach good composition. But by making you *aware* of the visual elements, they can guide you into a stronger way of seeing. The constant hammering away at principles, rules, and visual exercises may in fact arm you with somewhat of an unconscious evaluation process. Photography's greatest pitfall is that it draws too quickly. What goes through a photographer's head when the camera is pointed and the shutter is released?

You can be sure it is not thoughts of the many hours spent in a basic design course, hand-painting gray scales and matching them with color brightness charts for a solid fifteen weeks. Yet it is that perceptive evaluation that occurs at some point prior to pressing the shutter that separates the effective photographers from those with mere technical competence. It goes beyond approaching every subject as if it were the classical S-curve of a road that leads the eye to some distant point.

Some of the most effective photographers do not know what actually occurs when the shutter is released—other than that their head was totally involved with the subject. (Readers should be warned that asking this question of certain photographers can lead to lengthy, pseudointellectual oratory.)

At some point in this total involvement, an evaluation process has occurred. This may appear as only good common sense, but in fact it results only with thought. No matter how mundane it is, the subject

Christine DePalmer (page 90).
This photograph contains examples of
all three basic shapes. Do not overlook
the rectangular shape of the print.
Each shape expresses a visual
direction.

(Page 91).
Tone reinforces the appearance of
reality. Dark is perceived because it
abuts or overlaps what is light.

should be evaluated as if it were unique and as if it were being seen for the first time. This evaluation is then equated with a visual requirement and finally the appropriate technique for interpretation.

VISUAL ELEMENTS

A graphic approach to the nude model, where design principles play a more significant role in the overall success of the final photograph, can act to exemplify the evaluation process that appears to occur subconsciously. There are a number of visual elements with which to begin that are in one way or another applicable to all the arts: *line, shape, direction, tone, color, size,* and *texture.*

LINE

Line can be either abstract or real and is used most often to describe the juxtaposition of two tones such as the meeting of light and dark in a photograph which creates an abstract line. It is often difficult to make a distinction between a design element and the literal. If, for instance, you are photographing a nude model, you are photographing the literal. But if you are totally cognizant of the dominant vertical lines and strong diagonal lines, then you are reducing the nude to its visual elements. Since line can take many different forms which may convey very different moods, awareness of line congruity or incongruity is of the utmost importance.

SHAPE

Line describes shape either by the use of a single line that bends or curves or by several lines placed together. In relation to the human body, shape would be only the outward form or contour as distinguished from its substance or volume. There are three major shapes, each with their own unique characteristics: the square, the circle, and the equilateral triangle. Each basic shape suggests certain intangible concepts. The triangle, for instance, is felt to suggest action, conflict, or tension, while the more static square suggests boredom, dignity, or peace. The circle is the international symbol for security and suggests infinity or even intensity.

DIRECTION

Lines and the consequent shapes they form have a tendency to point or move the viewer through the photograph. Each of the basic shapes

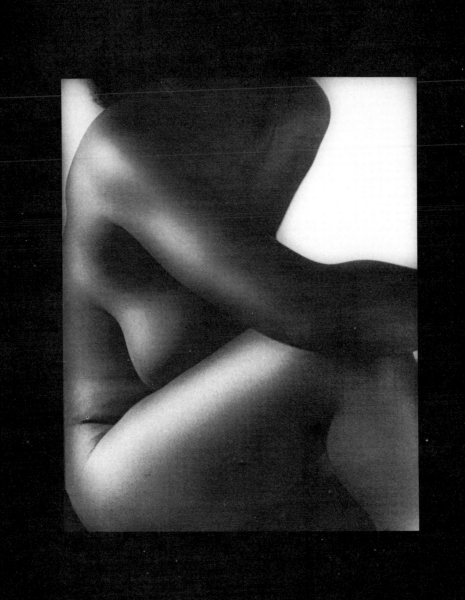

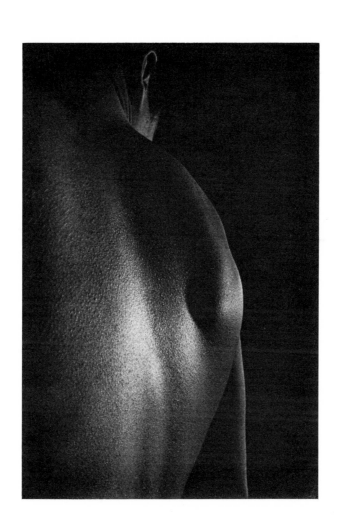

expresses a basic visual direction: the square expresses both horizontal and vertical direction; the triangle, diagonal direction; and the circle, a curve.

TONE

Tone provides contrast to line, and by its variation—in fact, the variation of light—the appearance of reality is reinforced. In black-and-white photography, tones are visual representations of colors and provide the dimensional qualities or substance to the shape of the human body.

COLOR

In black-and-white photographs, tones represent color; therefore, it can be safely assumed that color is not an absolutely essential visual element. In fact, the true test of a color photograph is based on how well it stands in its monochromatic interpretation. On the other hand, perception of color is the single most strongly emotional part of the visual process. More than any other element, color affects mood and can be used to reinforce visual information. Even subtle color changes in black-and-white prints, as in the use of a warm- versus a cold-tone paper or the use of a toning process, can irrevocably affect the final mood of the image. Colored mount board selection is not to be overlooked in its impact.

SIZE

Photography is dependent upon visual clues for size relationships because of the enormous scale change that is inherent in the media. Size is determined by juxtaposition; that is, there can be no large without small, and the entire scale can be changed by the inclusion of a third object. In nude photography, it is important to remember that humans intuitively base size on their own anatomy.

TEXTURE

The visual element of texture involves the viewer's sense of both the optical and the physical, for in fact texture can be appreciated by either sight or touch. Textural qualities inherent in the photographic media, such as grain clumping and the selection of printing paper and mat board surfaces, may all work with or against the illusion of texture in the photograph. Do not exclude smoothness as a textural quality (some photographers erroneously refer to certain surfaces as having no texture).

(Page 93).
The "optical" center is considered to be slightly left and higher than mathmatical center. Use of the optical center combined with basic direction principles contributes to the successful off-center placement of the subject.

(Page 94).
Grain is a textural quality inherent in the photographic medium.

(Page 95).
Note the subtle textural differences in skin, hair, and earring.

Barbara Vance-Halla (pages 96-97). With emphasis placed on the human form, the background suggests total congruity.

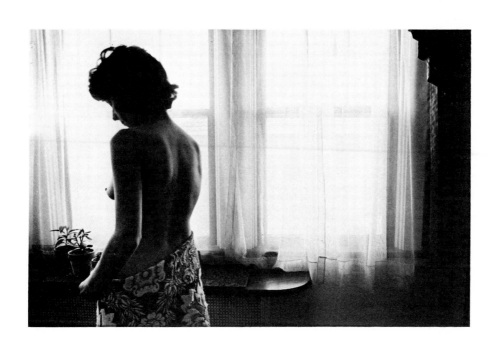

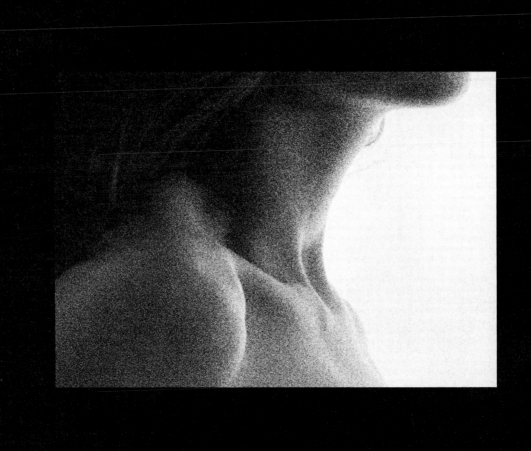

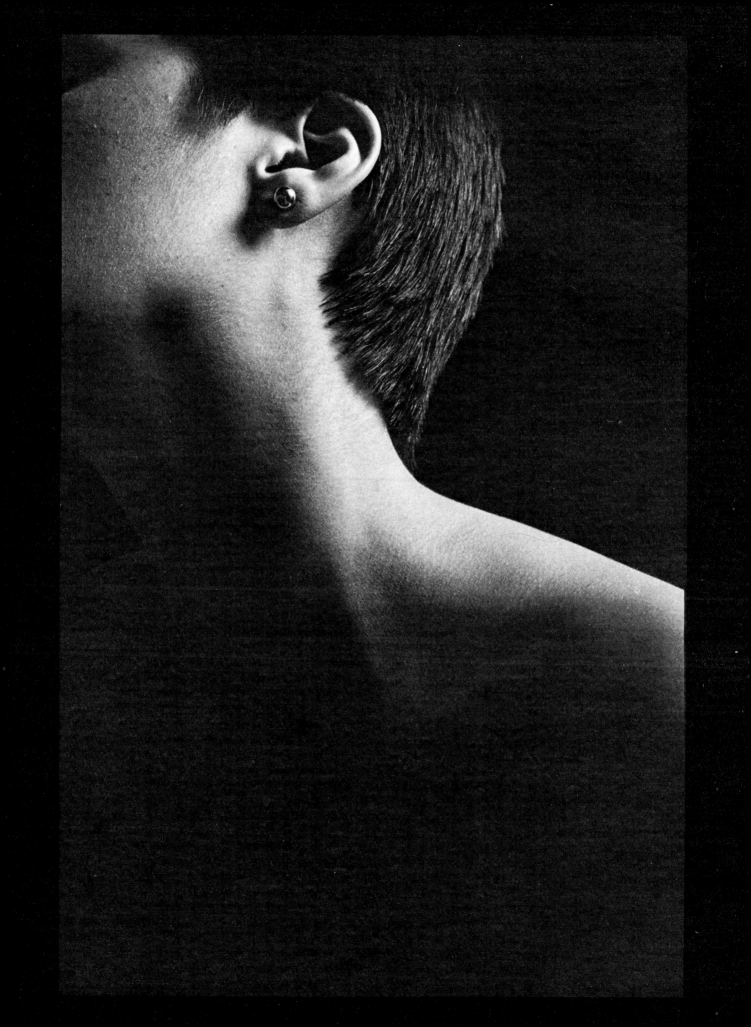

BACKGROUND
SELECTION

A thunder-gray seamless background, shielded from extraneous light, provides natural contrast with the model.

Whether you are working in a studio against a paper background or outdoors, the background should be in visual harmony with the total photograph. Harmony, or unity, is the photograph's bonding agent and will be strongly affected by the background selection.

With basic emphasis kept on the human form, the background can work to compliment or to contrast with it. The background can serve to make the nude stand out clearly by contrast or it may merely suggest compatability. Whatever your selection, you must develop an awareness of the background, that is, to be sure that you are not so involved with your immediate subject that you lose sight of the total picture. The classic example of the photograph showing a telephone pole growing out of a person's head is a result of subject-only involvement.

PAPER BACKGROUND

Once the decision has been made to use a paper background (*seamless*) the next determination is what color should be used. Since black-and-white film reduces colors to their tonal equivalents, it becomes even an easier decision—either dark, neutral, or light. If you are confined to the purchase of only one, a neutral seamless such as thunder gray appears to be a natural choice as it is visually lighter than dark skin tones and darker than light skin tones. Neutral toned seamless paper is also very adaptable to tonal change by controlling the light that falls on it. If you keep your model at a distance from the background and illuminate the subject only, the background will be rendered darker. If you illuminate the background with an equal amount of light as the subject or more, its tonal level may be raised to any degree. Flooded with light, a neutral seamless can be raised to the same tonal values as a much lighter seamless.

By basing the tonal selection and illumination of the background paper on a darker or lighter scale than the subject, a natural contrast can be provided. By selecting tones compatible with the subject and the background, you can hold separation to a minimum and make it dependent on the light falling on the subject. Only the areas directly illuminated will separate when photographing a dark-skinned model against a dark background.

A pattern can be created by casting shadows against an otherwise even-toned seamless background.

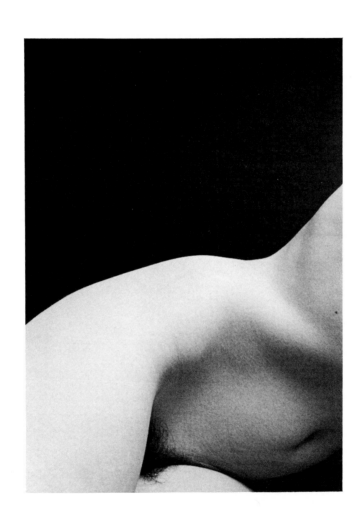

LOCATION BACKGROUNDS

Background brightness is no less important when working under natural light conditions. Backgrounds may be selected in terms of the illumination falling on them based on a scale darker or lighter than the subject. Additionally, location backgrounds may be selected to emphasize some aspect of the human form. This emphasis may be achieved through comparison or contrast of the nude with the background. With location work, visual dominance is of primary importance. The subject and the background must either work together as one total picture or be used in contrast, with this contrast providing the dominance and consequent unity.

For instance, the nude may be placed in juxtaposition with man-made or natural forms to emphasize the similarities. Or the nude can be photographed totally out of context for emphasis on one detail.

DIRECTING
THE MODEL

Excellent nude photographs are the result of a sum of different qualities: lighting, composition, posing, presentation, and your own individuality. This section is primarily devoted to controlling the visual forces in front of your camera by teaching nude model direction so you may quickly achieve your intended purpose.

WHY DIRECT?

When you are among a group of photographers shooting a nude, it is easier to crop in tightly on closeups of body portions than it is to selectively control the model. Under these conditions, whatever portion of the body is nearest the camera serves well to photograph. Several photographers working at one time make it difficult to direct the model to "move an arm to the right" or "twist the torso" without interfering with the others. In a group situation it is easier to rely upon the model's ability to select and regularly change a pose than it is to attempt directions.

As you approach your nude work with a greater degree of expertise, you will find that this type of shooting session becomes progressively less rewarding. Greater control over any situation directly improves the overall effectiveness of a photographer, in terms of both time and imagery.

As soon as you discover the intricacies involved in body placement—that is, placement of the torso, arms, legs, and head—the overall feel of the photograph will become your primary objective, not the

(Page 101).
Shadow patterns against an otherwise even background can create an interesting image.

Dennis S. Turocy (page 102).
Emphasis is achieved through contrast of the nude with the background.

R. Valentine Atkinson (page 103).
In this photograph the subject and the background both work together and are used in contrast. These qualities provide dominance and the consequent unity.

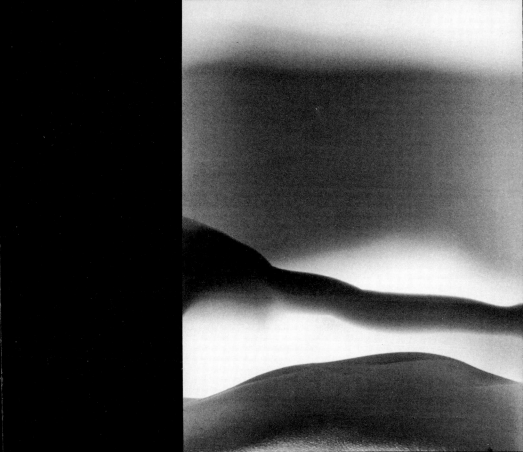

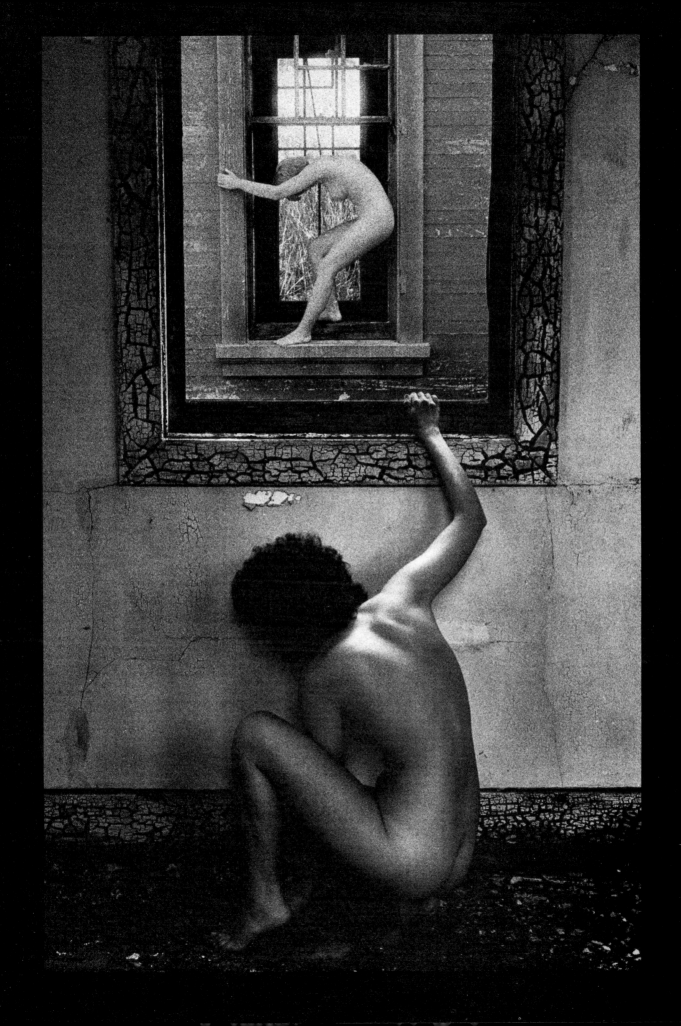

perfect placement of each element in the frame. When you reach this stage of your development, directing will become second nature and you will find yourself unconsciously breaking "the rules" to achieve effects appropriate to your final objectives. This section on body placement is designed to act as a point of future reference for the photographer to gain control of line, shape, direction, tone, size—most of the visual elements. As such it will include many commonly accepted rules which you may consider as guidelines rather than "never-to-be-broken laws." As long as you are aware of controls imposed by each body element, your visual perception and productivity will continually improve.

THE TORSO

The most simplified composition for torso shooting includes the model's chin, shoulders, breasts or chest, and hips. These basic elements can provide the photographer with an excellent starting point for directional exercises as well as the possibilities of some very rewarding imagery. First learn to photograph with the basic elements of the torso, observing the points in this section. With some practice you may extend the chin into partial facial forms and allow the arms to carefully enter the pictorial area.

Torso placement can create greater problems in dealing with the physical weight of the model than any other body components. In extreme cases, improper placement of the shoulders and hips can appear to add 30 percent additional weight to the model. Parallel shoulders, hips, and head on camera positions should be avoided for this very reason. Hips positioned flat toward the camera appear to add much more weight than do the shoulders in a similar position. And as a matter of pure aesthetics, the static symmetrical arrangement produced by parallel shoulders and hips appear, at best, to be a waste of delicate body lines. To keep the torso slenderized, let the hips face the camera as much as the shoulders or less, but never more.

By having the model raise his or her arms parallel with the shoulders or higher, the photographer can easily observe the direction and flow that the curve of the spine can provide. By shifting the model's weight from leg to leg and allowing the hip to project toward the weight-bearing leg, you can observe the spine following this pivotal action. The spine reacts to shoulder movements in the same manner. For instance, when the model raises the right shoulder and projects the left hip, the spine is automatically positioned in a C-curve. Movement of shoulders and hips directly affects the curvature of the spine and can create the most dramatic overall pose changes.

(Page 105).
The most simplified composition for torso shooting includes the model's chin, shoulders, breasts, and hips.

(Page 106).
In this example, hip placement "rules" are broken. Hips are positioned flat toward the camera while shoulders are turned slightly away. Because of this positioning, additional weight appears to be added to the model–in this case, to emphasize the maternal stomach characteristic of the 1930s.

(Page 107).
Observe the spine following the pivotal action of the shoulders and hips.

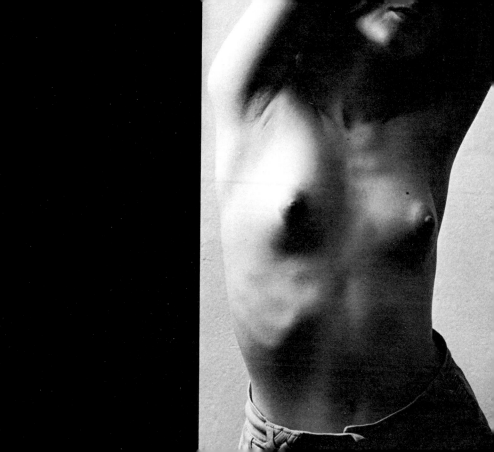

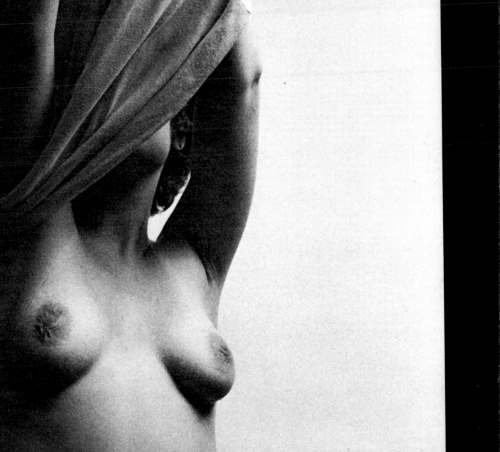

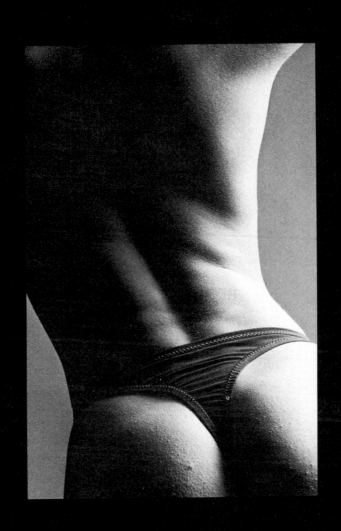

BREASTS

Photographically speaking, small to moderately sized breasts that are uplifted are by far the most desirable for female nude torso work. They can be photographed in most any position from full figure to tight closeups and from any angle with very few problems. Large, pendulous breasts are difficult to photograph, especially in the profile position. By keeping the model's shoulders and breasts facing the camera position, however, this problem is minimized. Another obvious but much more restrictive solution is to have the model raise her arms and shoulders, which will simultaneously raise the breastline. One particular shot to avoid is to have the model's back facing the camera with the breast protruding from her shadow side. The breast form will be recorded quite awkwardly and can actually appear as an elbow from a folded arm.

The breast itself should always be allowed to complete its own circular form. It should be noted that the rib cage reinforces the breast, repeats its shape, and can be used to assist the photographer in leading the viewer's eye movement toward areas of dominant interest. Images that crop the breast so tightly as to cut off natural shapes are rarely successful.

HANDS AND ARMS

Hands and arms added to the already complex torso require even more attention to subtle details. Because of their mobility that can cover entire lengths of the body, and their numerous, intricate planes, the hands and arms have a much more extensive list of rules covering their placement:

1. Avoid right angles from the camera's view. An arm pointed toward the camera will appear to be extremely large and distorted; an arm pointed directly away from the camera will appear to be miniaturized. Although this rule appears to be rather elementary, one particular area of the arm is often ignored. The elbow is most certainly part of the arm, yet many a potentially beautiful photograph has been literally destroyed by that wrinkled mass of flesh pointed directly toward the lens.

2. Place the arms away from the body so that they do not become part of the overall silhouette. Employing this rule will avoid optical confusion by keeping the body parts separated.

3. Do not show the hand and wrist without part of the forearm also showing. Especially on the shadow side or in full silhouette, hands and wrists appearing from the torso seem to be detached from the model and in severe cases may actually alter the model's profile.

4. Never let the flat palm of the hand face the camera position unless it is broken by the fingers or an object.

5. Arms should cross the body above or below the waist. An arm allowed to cross at the waist cuts the length of the body line and makes the waist appear heavier.

A restrictive but effective solution when photographing a large, pendulous breast in profile is to have the model raise her arm.

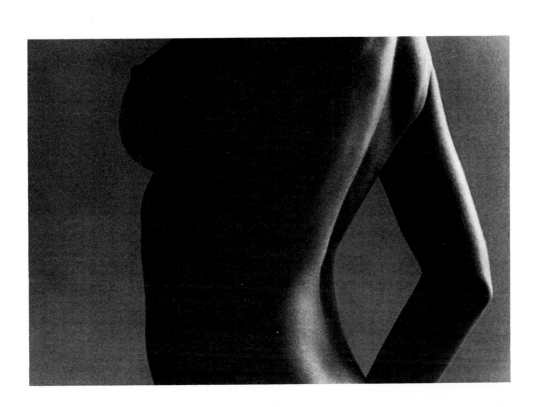

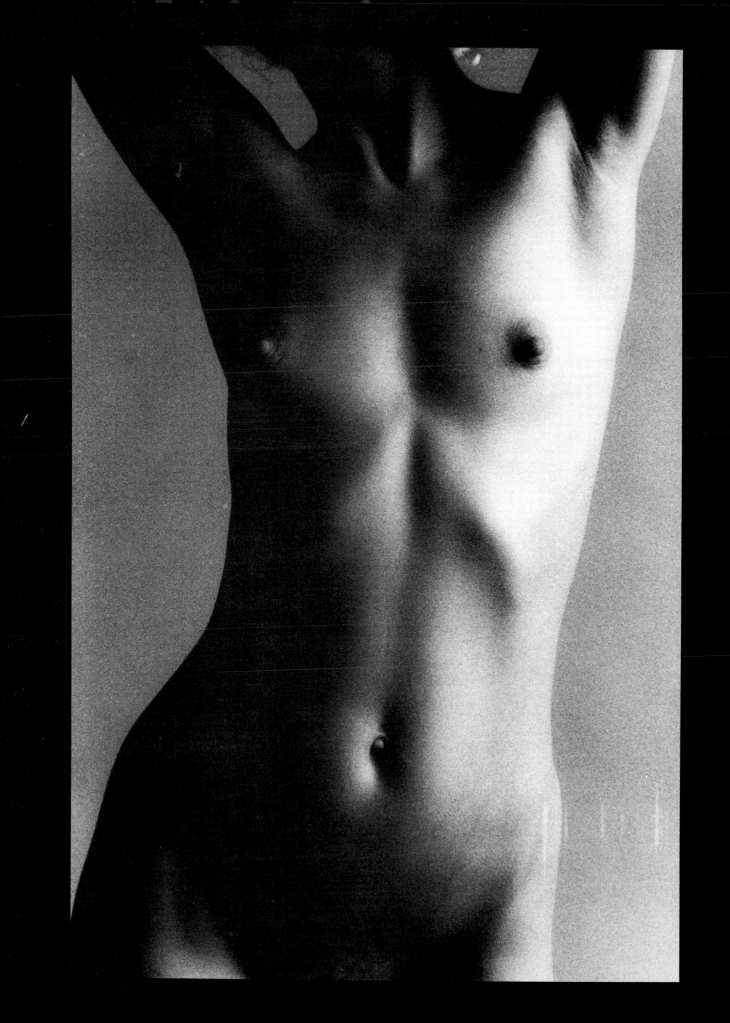

6. Avoid symmetrically balanced arms. Although this is a generalization, arms are so inherently full of direction that unless a specific effect is justified, they are bound to be more interesting with even subtle variations.

The following list of hand and arm placement rules may be applied to the female model by those photographers wishing to achieve what is thought to be the traditional concepts of femininity.

1. Flesh should never appear distorted by pressure. This rule can be applied to many types of poses. For instance, in a pose where the model leans forward and uses her arms for support, the pressure exerted on the muscles will severely distort the flesh. The upper arms are the real problem areas and demand special attention to avoid mashing them against the torso.

2. Female arms should be photographed slightly curved, never straight. The straight arm appears very masculine and definitely does not offer the graceful lines of a gentle curve.

3. Avoid straight wrists. The hand should be bent upward or downward from the wrist.

4. Never allow the back of the hand to face the camera—turn it slightly in either direction. The flat back of the hand reflects tremendous amounts of light if turned toward the main illumination and dominates a scene by both tone and shape. The blade of the hand facing toward the camera—achieved by a gentle twist of the hand —creates more delicate leading lines and has greater directional potential.

5. Fingers should follow the direction of any object they are holding. They should never grab or clutch anything.

6. Keep the model's shoulders low and to the rear. As the shoulders are moved forward, some tension is placed on the arms and the resulting photograph will relate a nervous, tense atmosphere. Beginning models—and photographers—are spotted by tense shoulders.

FEET AND LEGS

Quite often the immediate difference between right and left on our own bodies becomes most difficult to distinguish, and at best the usual "photographer's right is the model's left" method of direction becomes confusing. An alternative method is to refer to a floor clockwork position and a *basic* or *show foot* and *leg*.

This floor clockwork assumes the photographer is always at the twelve o'clock position, and depending on the mood of the photograph, the clock may be either small, medium, or large. The basic leg is simply the leg that bears the major portion of the body weight; that is, the model is primarily supported by this leg and foot. The show leg and foot, conversely, bear the minor body weight, or none of it at all. Because

**Camera position is
always 12 o'clock**

*Floor clockwork positions assume the
photographer is always at the twelve
o'clock position.*

of this, the show leg and foot have more freedom of movement and are
more readily used to provide interesting direction.

Whenever you are in doubt of leg placement, position
the left basic foot at eleven o'clock, or the right basic foot at one
o'clock, and try each number on the clock with the show foot, keeping
the next few rules in mind.

1. The toe of the show foot should never point toward
the basic foot until it has crossed the basic foot on the clock. Obviously this
will avoid pigeon-toed effects.

2. When the show leg crosses the basic leg, the toe
of the show foot may be parallel to, or point toward, but never
away from the basic foot.

3. The ankle may be straight or lean toward the instep,
but should never lean away from the instep.

Shifting of the body weight from leg to leg offers the
photographer an easy method of altering any poses—often quite
dramatically. With each gentle shift, allow the model's hip to always
project slightly toward the basic leg, but always as far away from the camera
position as possible. The hip severely jutting toward the camera should be
avoided with a female model as it is easily spotted as an overdramatized
cheesecake photographic technique.

Another problem area may be the knees. When they are
crossed or placed in profile, the knees should never be juxtaposed, as this
alignment will destroy separation of planes and cause confusion. Always see
that both knees are slightly bent to avoid "locked" knees and excessive skin
gathering at the kneecaps. With the knees bent, this excess skin will be
stretched and will provide smoother leg lines and a more natural stance.

(Pages 116 and 117).
Feet are juxtaposed and knees are "locked." The ankle of the show foot leans slightly toward the instep to add subtle "grace." Note that both knees are slightly bent.

When the body weight is equally on both feet, or when the model is walking, stepping up or down, resting on an object, or sitting, floor clock placement still follows all rules.

THE HEAD

When looking at a photograph showing a person, the viewer usually concentrates on the human head form and almost always seeks eye-to-eye contact. Because of this tendency, treatment of the head is an easily used device to control the viewer's eye direction and consequently the final flow through the photograph, even if you do not choose to provide facial detail. Many photographers prefer to render the face with minimal detail for a more universal approach. That is to say, when the model's face becomes a realistic representation of the model, most viewers relate to a specific person rather than to a timeless image. Other photographers specifically render faces to show who and what people are beyond the shapes of their bodies. Either approach, however, makes placement of the head nonetheless important and critical.

Because head shapes can be totally different from person to person, an extensive list of *dos* and *don'ts* would be ludicrous. The most important rule that must be established with the head form is the photographer's own awareness of its supportive qualities.

Head placement usually occurs after the "feel" of the overall photograph has been established by location of the other body parts—not because the head is any less significant, but rather because of the strong visual forces it can control. In many fine nude photographs, the head appears to take on a supportive function inasmuch as the final head position supports the entire composition and adds that final touch of flow. In fact, the head can make or break the picture, and undoubtedly can easily alter the final objective with a mere twist of the neck.

Basic head positions include tilting the forehead from side to side, tilting forward and backward, and turning the head at the neck. These movements or any combination of them, such as tilting the forehead backward and to the side, can be categorized as slight, moderate, or hard movements.

Tilting the forehead backward and simultaneously tilting hard to the side, away from the camera position, is a rather awkward position, as it accentuates the model's jawline. In this position, the placement of the eyes can produce various moods. With the eyes facing the camera they can indicate anything from suspicion to haughtiness, while looking upward they can serve to accentuate an elongated or muscular neckline.

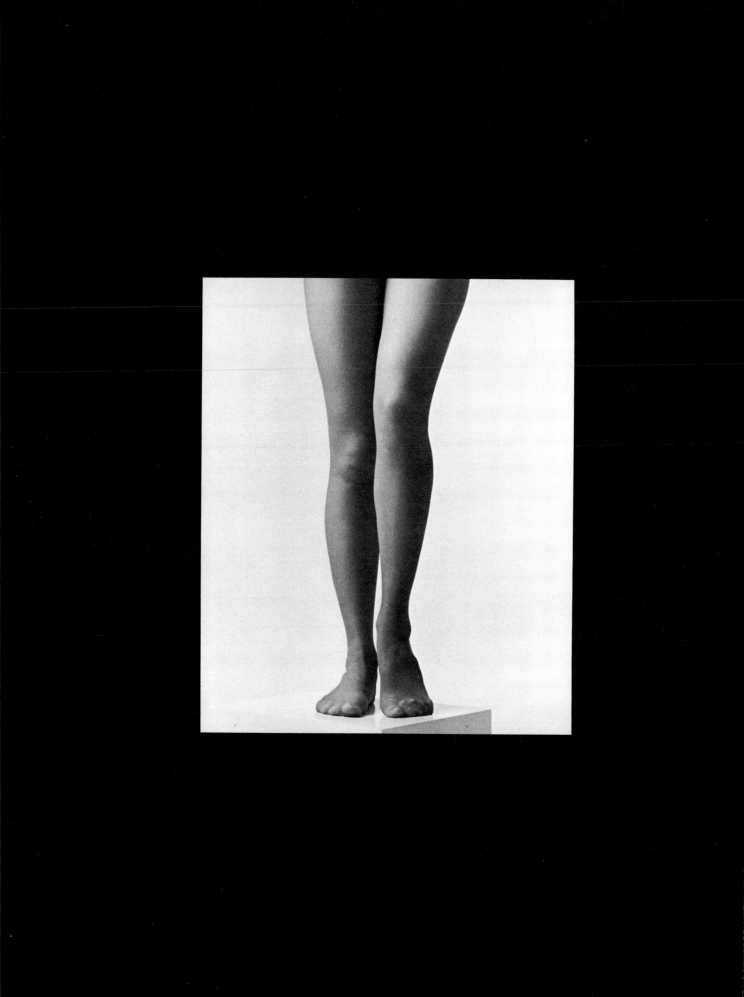

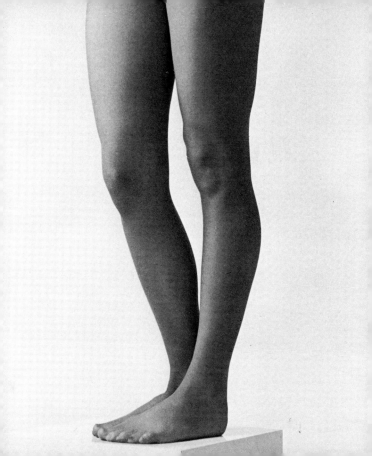

By moving the head to the opposite position, that is, tilting the forehead and tilting hard to the side nearest the camera, the model's neck becomes the area to watch carefully. Even very thin necklines have folds of flesh, which when positioned too severely can cause fatty line rolls which interfere with your composition. A particularly "attractive" combination of this movement would be to have the model tilt the head only moderately toward the side and then direct the model's eyes toward camera position. In most cases, this pose accentuates the eyes and literally grabs the viewer's attention.

When the model turns the head at the neck, the photographer must be careful again of the folds of the neckline. Too severe positioning can create lines in the neck that are next to impossible to deal with. The head should never be turned where the nose is in juxtaposition with the cheekline, as this angle destroys separation of both planes. If this does occur, have the model turn the head more or less to correct the error. In a turned position, no more than one-third of the pupil of the eye should ever be cut by the bridge of the nose, especially if the front eye is obscured, as this will cause a cross-eyed effect.

The head in full profile creates another problem with the eyes if they also are allowed to remain in the profile position. With the eyes placed at a 90-degree angle to the camera, very little of the pupil shows and the eyes appear as excessive amounts of white. Such positioning will make the model appear to be blind in the final print. To correct this situation, place the model's eyes at a 45-degree angle from the head position and toward the camera.

FIGURE VARIATIONS

Full-figure body variations are categorized into just a few basic types: straight line, S- and C-curves, reverse S- and C-curves, and the zigzag. These designations are arrived at very simply—the poses appear as their names suggest.

By drawing an imaginary axis line through the model's head, torso, and show leg, and visually connecting these major lines, you should learn to previsualize a continuous form that approximates one of the above designations. To test figure previsualization against your results, employ this same exercise by using a grease pencil on your contact sheets.

Current fashion magazines offer excellent reference material for both male and female pose variations. The fashion photographer deals regularly with model posing and offers the novice nude photographer a wealth of published visual examples to study and to emulate. Again, connect the major axis lines and equate them to your own work. You will soon see that the major pose categories are few—but the less apparent variations are many.

Note how the head is used to control the viewer's eye direction.

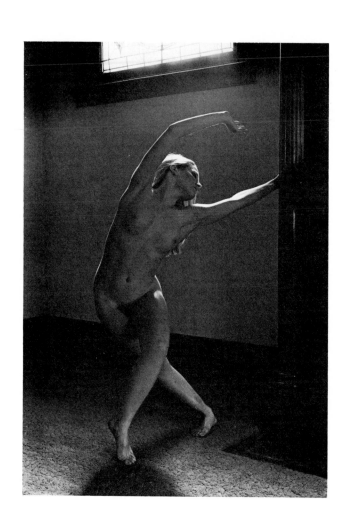

Debra P. Romanchak.
This graceful dance pose
overdramatizes a reverse C-curve.

SUMMARY

The beginning nude photographer often has the idea that each shot must be distinctly different from the last—and so he or she moves the model from a standing to a seated pose, from a front view to a back view, and so on. This idea couldn't be further from the truth. As was discussed throughout this section on body placement, slight variations can change entire compositions. The subtle variations in any one basic pose are endless.

Starting with any pose, the photographer may have the model shift the hips and shoulders and change body weight from leg to leg. Foot positions may be varied. Head placement can range from full frontal to a back-of-the-head shot, and hands and arms offer unlimited variations. Perspective has still yet to be explored.

The most effective nude photographs are often the most "simplistic" in appearance. That is, the successful nude photographer has the ability to "selectively eliminate" those details in the camera frame that are unessential to the final image.

By seriously studying various types of successful nude photographs, you will find that many simplistic images are, by their own directness, very complex. To build up confidence in your own imagery, it is suggested that you compose closeup portions of the torso and gradually add other body components. You will find it beneficial to be critical of your contact sheets, continually referring to the "rules" of body placement, as well as the many technical aspects involved in photography.

Do not stop the evaluation process as soon as you have found the best image. Continue looking at those unsuccessful shots and assess why they were unsuccessful. Was it because the arm crossed the waist and divided the torso, or because of too flat perspective rendering? Photograph and make mistakes that you are bound to make—then correct them. No reference book or bits of advice will ever replace the need for continued shooting and evaluation.

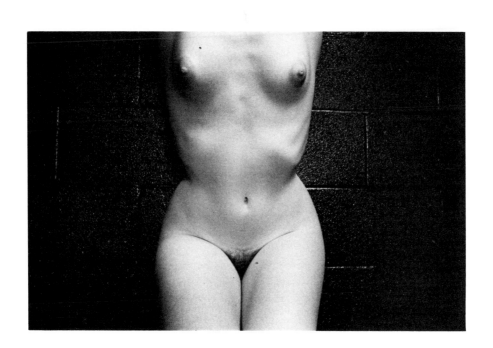

TECHNIQUES AS A VISUAL TOOL

LINE FILM FOR SHAPE RENDERING

Panchromatic films, such as Tri-X, record scenes in a series of gray tones ranging from black to white with each tone providing a spacial clue which creates the illusion of dimension in a final print. Eliminating the intermediate gray tones removes all hints of volume, and only a graphic shape representation remains with a two-dimensional flatness.

Line film, often referred to as "graphic arts film," is a film type designed to record only pure black and pure white. All shades of gray are forced into either black or white. Line films are available under many trade names (Kodalith, Cronar, and Ilfolith) and have many commercial applications such as in reproducing line graphs, illustrations, printed circuitry, and silkscreening. A typical line film has an ASA that ranges from 1½ to 6 and is available in 35mm bulk rolls or any of a variety of sheet film sizes.

There are three ways in which to record a nude on line film:

◇ By enlarging from another film
◇ By contact-printing from another film
◇ By shooting the film directly in the camera

The first two methods will yield a positive film image, while the last method will produce a negative image.

By far the easiest and most controllable method is to use line film for enlargements from your continuous-tone negatives. Line film may be used in much the same way as you would use any standard printing paper and is easily worked with under the manufacturer's recommended safelight.

ENLARGING ONTO LINE FILM

STEP 1: SELECT AN IMAGE. Continuous-tone negatives that are already on the contrasty side or that contain fine line detail seem to convert easily to line film. Negatives that contain subtle shades of gray with minimum or weak blacks and whites are more difficult to work with.

STEP 2: CHOOSE LINE FILM SIZE. Many photographers work directly with 4x5 sheet line film because this size is easy to control and to evaluate. If you do not have access to a 4x5 enlarger, you can still work on the 4x5 film, but enlarge only to the maximum size that your enlarger will accept.

An alternative method would be to enlarge onto even larger line film, such as 8x10, 11x14, or larger, and plan on contact-printing after the initial enlargement.

STEP 3: PREPARE FOR PROCESSING. Line film processing corresponds to any standard printing paper processing with the exception of the developer. Many manufacturers suggest the use of a two-solution line film developer. However, you can work quite successfully by using any continuous-tone developer. One of the most popular is Dektol diluted 1:1; at 70°F the line film should be processed for 3 minutes with constant agitation. The advantage of using a standard print developer is one of convenience only.

STEP 4: ENLARGE. As with any printing paper you are unfamiliar with, your first step should be to make a test strip of the image on the line film, then process and evaluate your results. The best exposure time should be determined by the test strip which contains the fullest blacks and richest whites. These areas should appear respectively as completely opaque and transparent. If the black or opaque areas have small irregular holes, this indicates a need for further exposure or development. If the black areas are totally opaque but the transparent areas have a slight gray fog, this indicates overexposure or overdevelopment. Make your final exposure on the line film, process, wash, and dry.

STEP 5: OPAQUE. Photo-Opaque is a heavy, tenacious pigment designed to prevent light from passing through portions of the film. The use of opaque involves painting on the film and allows you additional control over your image. By slightly diluting the opaque with water and applying it to the film with a brush, you can alter or eliminate entire areas of the image. It can be applied either to the emulsion or base side of the film, and because it is water-soluble, if you make a mistake you can wash it off.

STEP 6: CONTACT-PRINT. The line image you have produced from your continuous-tone negative is presently in a positive form. If you were to place it in your enlarger and print it as is, it would yield a negative print. The idea is now to convert the film positive into a film negative stage. By contact-printing your positive image with a fresh sheet of film, placed emulsion to emulsion in intimate contact, and reexposing to a light source, a negative will be produced. Begin by making a test strip to determine the proper contact exposure, evaluate the same way you evaluated the film positive, and make your final exposure. Once your negative is dry, you can apply Photo-Opaque as you did on the positive version. At this point, your negative is ready for printing. It should be noted, however, that this positive-to-negative process can be carried out indefinitely until you are pleased with your results.

STEP 7: PRINT THE NEGATIVE. With a properly produced line negative, it will make no difference what printing grade of paper is used for the final enlargement. The negative has been reduced to pure black and white

A properly produced line negative should be completely opaque/transparent and should print easily on any paper grade.

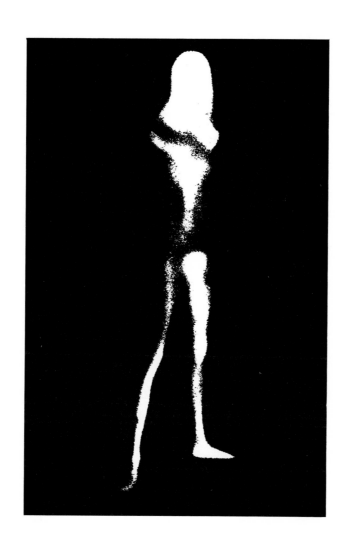

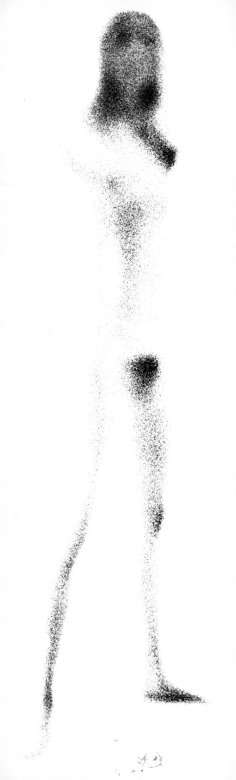

tones, and the print exposure time should be adjusted to reach the maximum black of the printing paper.

2475 RECORDING FILM FOR TEXTURE

In nude photography, grain can be used to create a variety of different moods. It can minimize the identity of the model while still retaining sharpness of focus, and can cause a hard-edged subject to appear soft and a soft image hard. But most importantly, grain provides a texture that unites all areas of the photograph and ties the entire surface together.

Photographers and film manufacturers have worked to minimize excessive grain. (It should be noted, however, that grain is inherent in the photographic process and can be used visually to emphasize the very structure on which photography is based.) Even in many high-speed films, modern emulsions have been so refined that it is often hard to produce really grainy prints. There are several methods of adding noticeable grain to the photographic image, however, and proper film selection is the most direct.

Kodak 2475 Recording Film, most commonly associated with low-light-level police surveillance work, is an excellent film that can provide excessive grain and still retain a relatively high degree of sharpness. The manufacturer's suggested ASA of 1000 can vary directly with shadow detail, resolution, contrast, and grain size. The film may be rated anywhere from ASA 800 to ASA 6400. In general, ASA 800 is usually used under flat umbrella lighting in a studio situation, while ASA 6400 is rarely used and should be considered variable and experimental. As a rule, and in line with Kodak's recommendations, ASA 1600 is a satisfactory rating for a starting point.

The following summarizes results with 2475 Recording Film at different film speeds:

◇ ASA 800 with Kodak DK-50 Developer
 6 minutes at 70°F
 Excellent shadow detail, good sharpness, coarse grain
◇ ASA 1000/1600 with Kodak DK-50 Developer
 6 minutes at 70°F
 Same development, normal shadow detail, noticeable increase in contrast
◇ ASA 3200 with Acufine Developer
 6½ minutes at 70°F
 Normal printing contrast, increased grain, better shadow detail than ASA 1600, good sharpness retained

◇ ASA 4000 with Kodak DK-50 Developer

9 minutes at 70°F

Increase in contrast, poor shadow detail, grain increase

◇ ASA 6400 with Diafine Developer

3 minutes at 70°F in each of solutions A and B as per instructions

Film rinsed for 1 minute, redeveloped for 2 minutes in each solution; high fog level, low shadow detail, sharpness OK

Many professionals agree on the nonrecommended process of rating Recording Film at ASA 3200 and developing in Acufine. A normal print contrast is produced with a noticeable grain increase over the manufacturer's recommended development (but that is why you chose the film stock to begin with). However, shadow detail is far superior to any other devices in this speed range.

The only development problem that might be encountered in any of these processes is tonal irregularities, streaks, or clumping of grain, all usually occurring in the neutral to light areas of the negative. This problem can be traced to improper agitation of the film and shows more readily in a negative of lower contrast produced by such a high-speed film. If this fault persists after you have carefully reevaluated your agitation procedures, it is suggested that you treat your negatives, especially those of a high-key nature, to a 1-minute water presoak before development. This presoak will soften and uniformly wet the emulsion so that when the developer comes in contact with the film, a more equalized and complete action occurs.

PRINT TONING: COLOR ALTERATION

By working directly on the silver image, print-toning processes convert black-and-white prints to a desired color and, as an added feature, make them more permanent. All toning processes are directly affected by the silver structure of the printing paper, which in turn is determined by paper selection and processing procedure. An empirical rule of thumb indicates that cold-tone papers generally react better to the bleach and redeveloper toners, while warm-tone papers react well in direct toners.

Print-processing procedures alter the silver structure of the paper and should be followed methodically for consistent and optimum toning results.

Do Not

◇ Overexpose the print paper, as the grain structure will be altered.

◇ Overfix, because fix will penetrate the pulp of the paper and it becomes increasingly difficult to remove. Prolonged fixing can bleach prints and actually change the image tone.

R. Valentine Atkinson. Kodak 2475 Recording Film, usually associated with low-light police surveillance work, renders a textured effect appropriate to some nude studies. Notice the tight, regular grain structure in this natural light application.

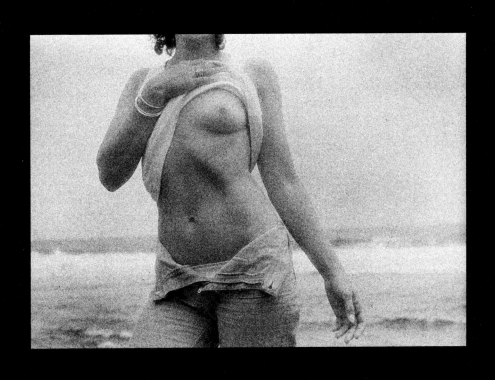

Do

◇ Use a full 2-minute development time.
◇ Use a minimum fix time.
◇ Use a hypo-clearing agent.
◇ Ensure thorough washing procedures.

SELENIUM TONER. Selenium toner is a direct single-step toner and on warm-tone papers will produce cold brown tones. The change in tone is progressive and can be stopped when the desired color is reached. Follow the manufacturer's suggested procedures for optimum results.

Selenium is an ideal toner for strengthening the blacks on a cold-tone print without a perceptible color change. Because the toning occurs so gradually, it is suggested that you have an untoned control print to follow the toning action and to use for a comparison. Many photographers favor selenium toner because it eliminates greenish-black characteristics common to some cold-tone papers and because it makes the image highly permanent.

A popular working procedure is to mix 25–50 milliliters of selenium toner per quart of working-strength hypo-clearing agent maintained at 75–80°F. Place the prints you have selected for this process directly into the toning solution from the hypo bath. Thoroughly drain the prints but do not use a water rinse. After 5 minutes of constant agitation, you should refer to your untoned print for a tonal and color comparison.

SEPIA TONER. Sepia toner is a two-step bleach and redeveloping toner that produces brown tones ranging from yellow-brown through sepia to deep browns, mainly depending upon the paper type. Because of the overall image bleaching process, it is necessary for prints to be exposed slightly darker than normal when developed normally, that is, the print must have veiled highlights.

In most cases follow the manufacturer's specific recommendations; however, be aware that a colder tone of brown can be obtained by deviating from the usual procedures. Instead of following the bleach-redevelopment sequence, immerse the print first in the redeveloper for 2 minutes, rinse thoroughly, and then follow the recommended bleach-redevelopment steps.

INFRARED FILM FOR TONE ALTERATION

In the early years of photography, the person behind the camera was often faced with many problems due to the poor technical advances of such a young art. During the initial exposure, for instance, one of the problems encountered with strong highlights was reexposure of the film from the backing. That is, when strong highlights were photographed, the intense light would pass through the emulsion, strike the film base, and reflect the light back into the emulsion, thereby causing a "halo."

Addition of the warm brown tones unique to sepia toner would create a certain congruity to the skin tones of the model and the projected wood texture.

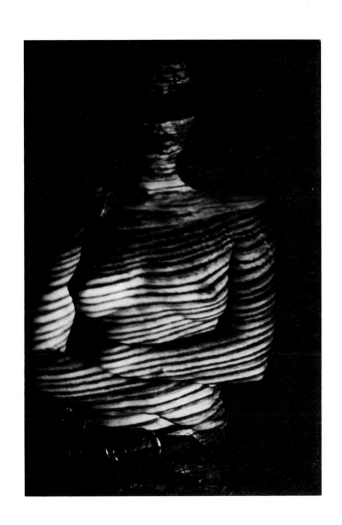

In the modern emulsions presently available, this halation is largely eliminated by antihalation backing dyes which absorb most of this extraneous light. Only under the most severe conditions will his halation now occur. However, the photographer of nudes often attempts to duplicate this effect for various reasons. Halation effects take away the hard-edge qualities of high-resolution film and offer a softer alternative. In the process, this loss of resolution tends to subdue tonal imperfections in skin tones.

One solution used to achieve a halation effect and otherwise obtain soft, unblemished qualities in nude photographs is to use black-and-white infrared film. Prior to a test-shooting session with this film type, however, the photographer should be aware of basic differences between infrared and normal panchromatic films. Panchromatic film is sensitive to the visible light spectrum and, as are all films, to ultraviolet light. Infrared film, quite simply, is dye-sensitized to extend its sensitivity below the visible-light range to a point approaching heat. Skin tones photographed with infrared film reflect and transmit infrared differently from the way they behave with visible light. As an example, red skin blemishes do not record on infrared materials because these defects reflect equal amounts of infrared as the surrounding, unblemished skin.

Infrared light is not focused by a standard camera lens at the same place as visible light; therefore, a focusing correction on the lens barrel must be made. When using infrared film, you must establish a slightly-longer-than-normal lens-to-film distance. Most small-format cameras have lens-focusing scales with an additional datum mark for infrared. Focus on the nude as usual, observe the distance on the footage scale, and transfer this distance to the infrared mark. If your lens is not so equipped, increase the lens-to-film distance an additional 3 percent of the overal focus (roughly ⅛″). An added focusing precaution is to work at the smallest possible aperture so that the additional depth of field will overcome small focusing errors.

HANDLE IN DARKNESS. Kodak High Speed Infrared Film is specifically marked with this warning: "Film must be handled and kept in absolute

Dennis S. Turocy (page 133). Soft, unblemished images with a slight halation effect are characteristic of well-exposed high-speed infrared film.

(Page 134). The same situation as on page 135–torso and black thong–shot with high-speed infrared film. The soft effect and slight halation is achieved by optimum exposure.

(Page 135). A torso with a black thong photographed with common panchromatic film.

An additional datum mark for infrared focusing is found on most small-format cameras, as shown.

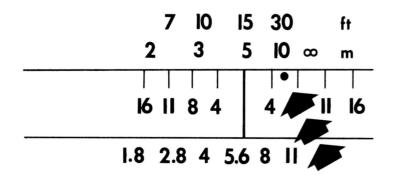

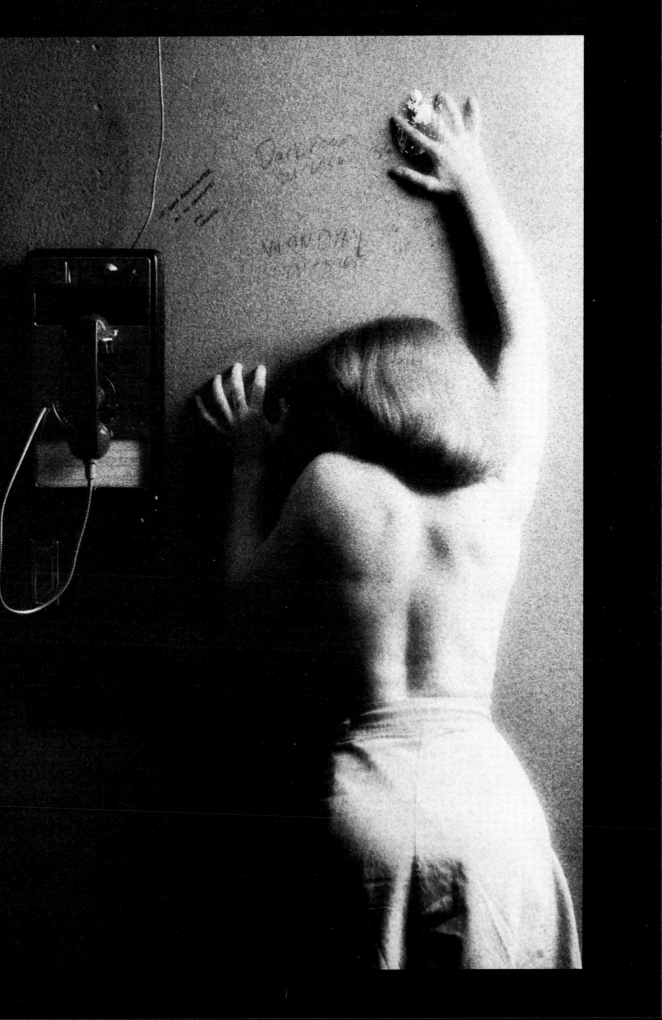

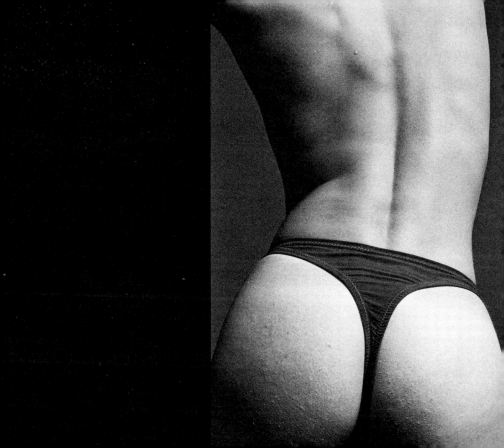

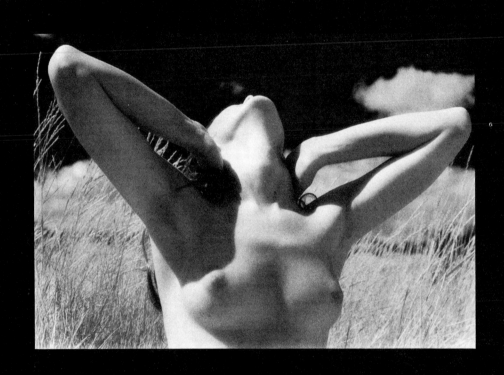

Steven Franklin.
Infrared film employed in the
environment can produce exciting
results. It is suggested that the
photographer maintain notes on film
reaction.

darkness until processed. Do not open can, load or unload camera except in absolute darkness." Because the film cassette is incapable of preventing infrared radiation from exposing the film through the felt light trap, failure to follow this precaution may result in fogged film. This warning is quite easy to remember when loading your camera, but after a zealous shooting session, many a photographer has absentmindedly opened the camera back to reload quickly . . .

TEST THE FILM. As with any film you are not familiar with, it is suggested that you make several tests with infrared film prior to any critical shooting sessions. This is all the more important when using infrared film, as the results are atypical of most films.

The manufacturer's suggested exposure index, ranging from 10 to 200, provides an excellent stepping-off point; however, since light meters are calibrated for visible light and do not record infrared waves, bracketing exposures under various lighting conditions is essential for optimum results. Incidentally, a tungsten bulb and an electronic flash both emit roughly the same amounts of infrared, so the choice of either depends strictly on the photographer's preference. If you use a 25A red filter in front of the camera lens, some of the visible light does pass on to the film, but meter readings, in this instance, are still approximations.

FILM REACTION. You will observe that infrared results also differ according to the skin tone of the model, color of the hair, and in many cases the fabrics included in the image. Black backgrounds, for instance, record closer to a neutral gray tone. Rather than making many oversimplified generalizations, it is suggested that the photographer maintain notes on skin tones and various surfaces.

With optimum exposure, infrared film produces a halation effect resulting from strong highlights. With the slightest overexposure, loss of resolution occurs rapidly as grain increases and the halation effect is magnified. This occurrence is probably more accurately described as *irradiation*—the spreading of light within the emulsion layer, exposing silver halide crystals surrounding the highlight areas. Irradiation and the consequent halation effect occur most quickly with thick film emulsions and with overexposure.

LOCAL BLEACHING FOR TONE ALTERATION

Before you regard a print finished and ready for presentation, here is a procedure you may want to consider—local bleaching.

There are many instances where a slight degree more control of the printed tones can make the difference between a mediocre print and an outstanding print. For example, a weak highlight that can be accentuated can literally alter an entire composition.

Potassium ferricyanide can be used to bleach entire areas, as shown in these "before" and "after" examples (pages 139 and 141). Application was made with a brush around the figure and with cotton swabs in the larger areas.

Potassium ferricyanide can be used as a bleach to reduce the overall density of a print, or, most importantly, can be used locally to clean up highlights or to relieve details that would otherwise remain subdued.

PREPARATION. In preparation for local bleaching, assemble the following:

◇ Potassium ferricyanide diluted with water
◇ Hypo (sodium thiosulfate)
◇ Sheet of thick plastic or a print tray with a clean back on which to place the wet print
◇ Fine-tipped brush or cotton swab or cotton ball
◇ Lint-free cloth for wiping print
◇ Test print
◇ Work area with running water

If the print that is an ideal candidate for bleaching is already dry, soak it in plain water until it is soft and pliable. Otherwise, a print that has been taken through the customary processing steps and has just been washed is ready for local bleaching.

Mix the potassium ferricyanide crystals with enough water to approximate a lemonade color. Have fresh hypo available in a second container. Take a test print from the wash and place it on the back of a clean tray or other suitable surface and blot the excess water from the print with a lint-free cloth so that when bleach is applied it will stay where it is put rather than running with the water patterns.

APPLICATION TO PRINT. Personal preferences and working area size will dictate whether you use a brush, swab, or a cotton ball to apply the bleach. Assuming you will be using a swab, dip the swab first in the hypo and squeeze out the excess. Then dip the swab in the potassium ferricyanide solution and lightly apply to the print surface. If the bleach reacts too quickly, further dilute the mixture and test again.

Learn to work progressively with the bleach rather than rushing. That is, apply the bleach and stop the action with running water. The area you are working on will gradually lighten. After several applications, the print may absorb enough bleach to cause a yellow stain which will disappear in a fix solution. After you are satisfied that your print bleaching is completed, place the print in a fixing bath, rewash, and dry as usual.

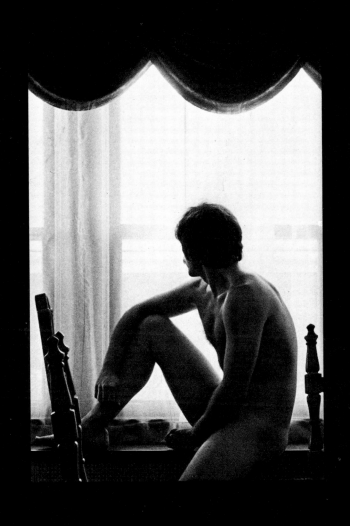

THE ILLUSION OF MOTION

A still photograph cannot literally show motion, but the illusion of motion can be portrayed by a number of methods:

◇ Stop-action
◇ Subject blur with background sharpness
◇ Subject sharpness with background blur
◇ Multiple exposure
◇ Sequential portrayal of separate images

With any stop-action photography, the illusion of motion is dependent upon the viewer anticipating the continuation of action. Stop-action may be an appropriate and forceful method of implying motion; all the work, however, is left to the viewer. The only technical requirement is in selecting a shutter speed fast enough to stop the action or by using an electronic flash unit.

When photographing nudes in motion, there are no set rules for matching shutter speeds with the action. Any number of variations can produce pleasing results. A slower shutter speed may be used in two ways. First, usually with the camera mounted on a tripod, a slow shutter speed will allow the moving nude to blur slightly, while any stationary objects will record sharply in focus. The blurred model will create a strong impression of motion. Panning the camera with the motion, however, will not only create the illusion of motion, but will also draw the viewer into the action. When panning, the photographer follows the moving nude with the camera, keeping the nude relatively sharp while the background records as a blur.

Similarly, two or more images photographed slightly out of register with each other, or with different image sizes on the same piece of film, will also produce an illusion of motion. Multiple exposures with overlapping images is accomplished by multiplying the film's ASA by the number of desired exposures and then photographing each exposure at that new ASA without advancing the film. The idea is that with a number of exposures, the film density will build up to one normal exposure. By making two or more normal exposures on a single piece of film without changing the ASA or otherwise compensating for additional exposure, the film will be overexposed.

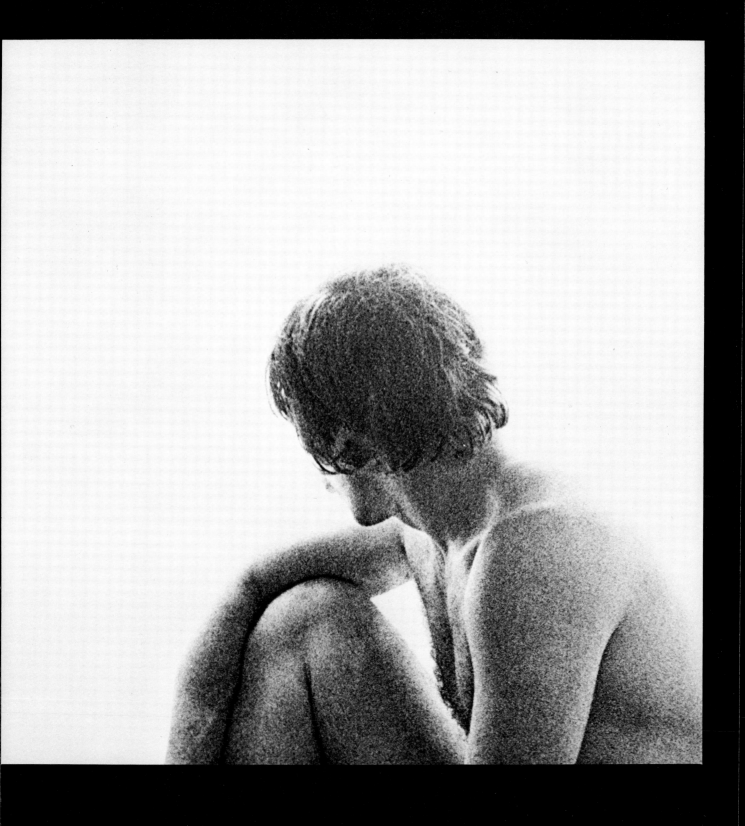

Craig Morey (page 143).
Slight subject blur with stationary objects recorded sharply creates a strong impression of motion.

Photos by Deborah Stanton (page 144).

Dan Hucko (page 145).
Multiple exposures with overlapping images tend to draw the viewer into the illusion of action.

Example: When you are using Tri-X film with an ASA of 400 and are planning two exposures on a single frame, multiply $2 \times 400 = $ ASA 800. Thus, shoot each of the two exposures at ASA 800. For three exposures, shoot each at $3 \times 400 = $ ASA 1200; and so on.

Many cameras have clutch overrides that will allow the film to remain stationary through any number of exposures. Other cameras require special methods of rewinding the film to make more than one exposure on the same frame. If in doubt, refer to your camera manual.

Multiple exposures with images that do not overlap and are being photographed against a black background require no exposure compensation.

Separate images shot and presented in a logical order involve the viewer with a temporal sequence and can form a forceful presentation with a strong suggestion of motion. Photographers rarely think of sequential or series work in relation to motion, but the concept is so closely allied with filmmaking that it becomes a natural.

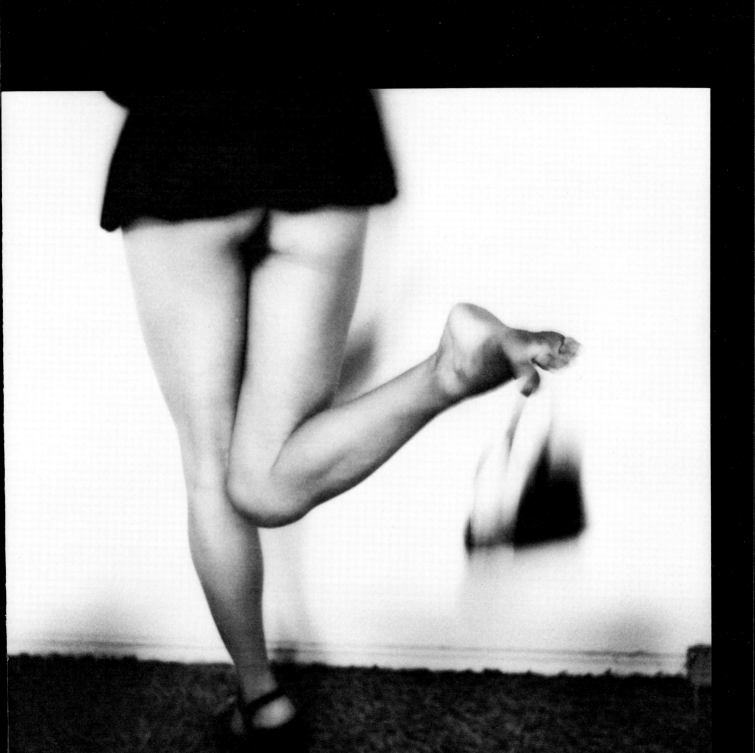

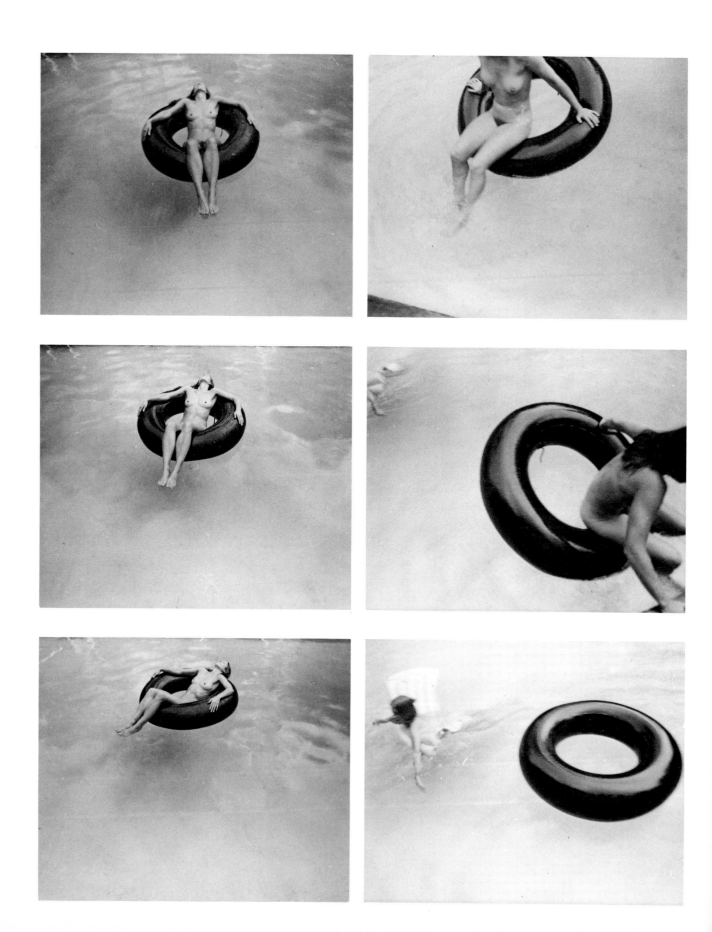

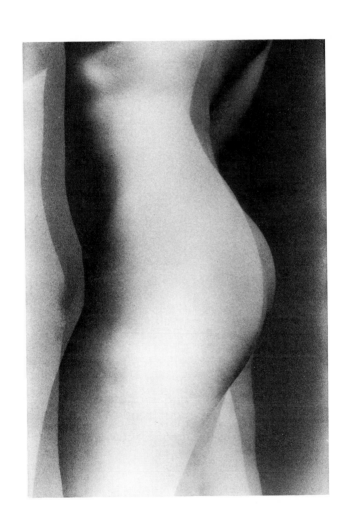

Photo by R. Valentine Atkinson

STRUCTURAL APPLICATIONS

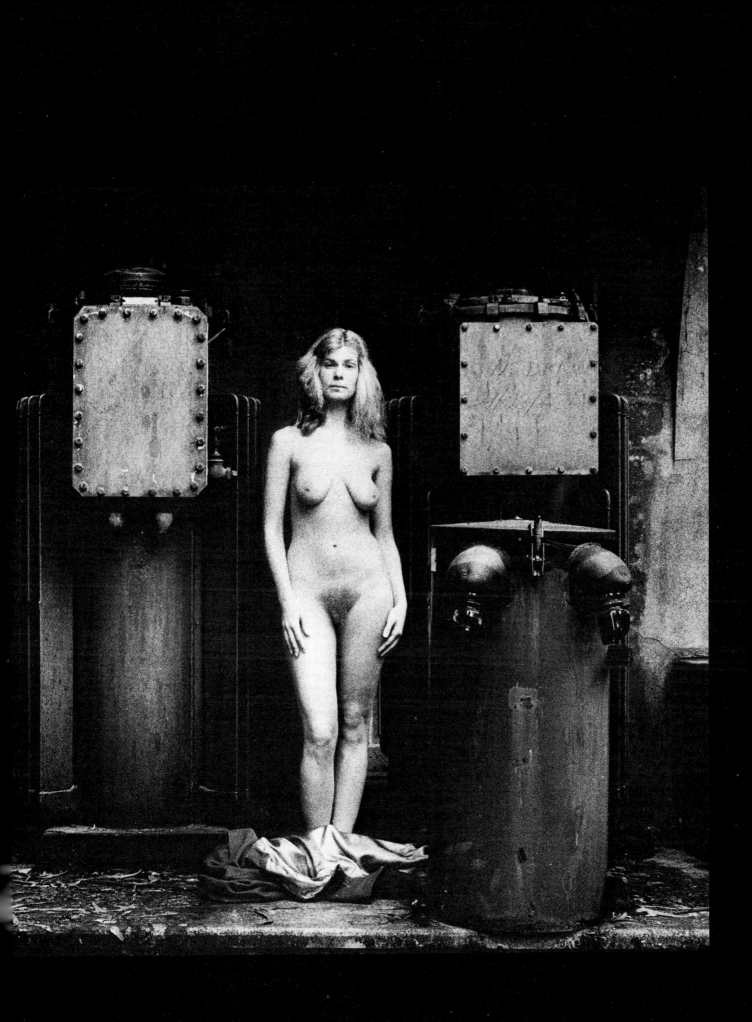

The photographs in this section have been carefully selected to illustrate a broad spectrum of visual principles applied to the human form. Although these principles are heavily captioned, this is not intended to imply that design principles alone make these images successful—for as you know, excellent photographs are the result of a sum of different qualities.

As a photographer of the human form, you have the responsibility to use what is made available to you—arranging the visual elements into a satisfying order of beauty and variety without becoming monotonous or confusing. You have the responsibility of design, that is, to see the nude in the strongest way. Good visual design sense is a matter of personal growth; or more simply, it must be developed by continued visual exercises and evaluation. There is no other form of photography where design principles are so clearly exemplified or where they play a more significant role.

BALANCE

When an imaginary vertical center line is placed on a photograph and all visual elements to the left and right of the line are identical, the balance is referred to as *symmetrical,* as in this example. With an *asymmetrical* balance, all visual elements are reduced to their optical weight, and require appropriate distribution.

Deborah Stanton (page 151).

Photo by D. Varos (page 152).

Photo by Craig Morey (page 153).

SEQUENCE

Although in Western culture the eye is accustomed to traveling from left to right and top to bottom, the sequence of visual elements can create an optical rhythm. Eye travel can be started anywhere and directed throughout the photograph. (See photo opposite).

PROPORTION

It is accepted that standard mathematical relationships within a print should be avoided. A square with four equal sides, then, becomes a weaker presentation than a rectangle; however, in the examples on pages 152 and 153, the square format optically appears vertical.

EMPHASIS

In the delicate example in Goldman's photo opposite, emphasis is achieved by a subtle combination of all the visual elements. In the photo on page 156, this image depends on the positive/negative concept for emphasis. This concept is not meant to describe darkness or lightness; rather, what dominates the eye is the positive element. More passive elements would be negative.

REPETITION

The repetition of form apparent in the photographs on page 157 and at the opening of this chapter is the cohesive force that holds the diverse compositions together.

Photo by Kim Robert Chambers (page 159).

Photo by R. Valentine Atkinson (page 161).

DIMENSIONAL QUALITIES

Photographs are two-dimensional representations of a three-dimensional world; the illusion of mass in any solid object must be formed. In these examples (pages 159 and 160), highlights are played against shadows in various degrees to create the illusion of dimension.

SELECTIVE FOCUS

The usual selective focus example would show part of the image rendered critically sharp and the remaining areas out of focus. However, "selective focus" indicates the photographer's ability to select the areas of focus pertinent to the image (see photo on page 161).

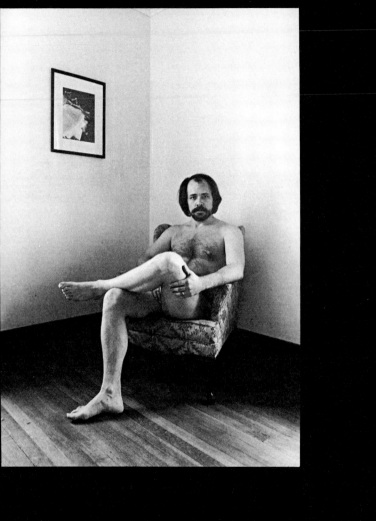

Photos by D. Varos (pages 164-65).

DOUBLE
EXPOSURE

Careful control of all the variables is attributed to the success of the
distinctly different double exposures on pages 164 and 165. The
photographer used only one light source, which was moved between
exposures. An example of two negatives separately photographed against a
dark background and "sandwiched" in the printing stage to form one image
is shown in the photo opposite. By controlling this effect in the printing
process rather than in the unpredictable double-exposure in-the-camera
method, the photographer gains additional control.

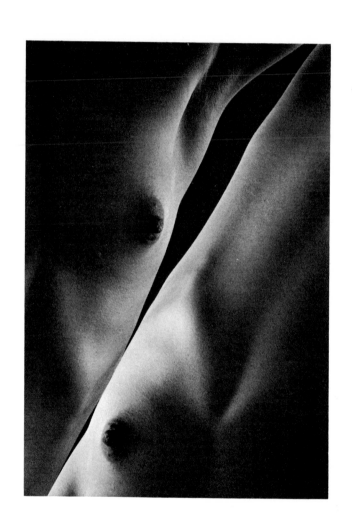

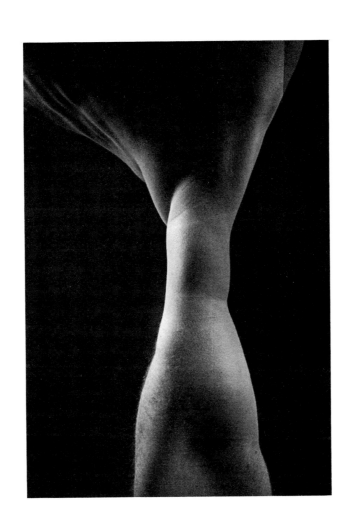

THE COLLAGE

Unlike many collages, this photograph does not hide its paste-up qualities. Rather, the photographer has used inlaid strips of white photographic paper for emphasis on the procedure. The model was originally photographed on 35mm Tri-X, converted with a weak exposure onto line film, collaged, and finally copied onto 4x5 Tri-X film.

THE MONTAGE

The photographic montage—a composite made by superimposing several
different pictures upon one another—often combines various techniques,
as in this example.

BETWEEN-
THE-FRAME

Between-the-frame images discovered on a contact shelf or self-assigned for a shooting project can produce images no other way obtainable (photo at right). In the other two photos (pp. 172-73), these between-the-frame shots combine graphic flatness and strong dimensional qualities all in the same image.

Unknown.
The author captured during an early
exposure.

INDEX

note: Page references in italics refer to photographs.

A

Acufine Developer, 127, 128
aluminum foil, use of, 36, 37
ambient light reading, 41
angle of incidence, 37
angle of reflection, 37
aperture, 68, 132
arc lights, 20
artificial light:
 advantages of, 12
 application of, 17
 control of, 12, 14, 17, 20
 disadvantages of, 12
 ad modeling, 14
 vs. natural, 10, 12
 and shadow elimination, 14
 as source, 10, 12, 14
 See also Light; Lights
Atkinson, R. Valentine, *85, 103, 129, 146, 161*
axis lighting, 44, 47

B

background:
 awareness to, 98
 brightness of, 48, 100
 complimentary, 98
 contrasting, 98
 harmony of, 98
 light in, 44, 48
 model separation from, 41, 44, 48, 51, 98, 100
 selection of, 98, 100
 in sunlight, 28, 36
 tone of, 44, 47, 51, 98
 unity of, 98
background lighting, 47, 51, 98
background paper, seamless:
 color of, 98
 lighting of, 98
 substitute for, 53
balance:
 asymmetrical, 148
 symmetrical, 147, 148
barndoor, used to control light, 26
beam-candlepower-seconds (BCPS) rating, 24
between-the-frame, 170
black-and-white photography:
 contrast filters for, 66
 fill light for, 37
 tone in, 92
 umbrella lighting for, 27
bleaching, local:
 equipment for, 138
 preparation for, 138
 print application, 138
 with potassium ferricyanide, 138

bleed mounting, 78
body parts, posing of:
 arms, 108, 111
 breasts, 108
 eyes, 28, 116
 feet, 111, 121
 hands, 108, 111
 isolation of, 44, 71, 108
 legs, 111, 121
 neck, 116
 toes, 111, 121
 torso, 104, 121
 wrists, 111
 See also indiv. body parts
breast, posing of:
 angle of photograph, 108
 in profile, 108
 size factor in, 108
broad lighting, 42, 43, 44
butterfly lighting, 42–43

C

cable release, 71
camera(s):
 Canon, 59
 Diana, 120, 58
 hand-held, 61, 72
 Instamatic, 58
 large-format, 6, 61
 Nikon, 59
 SLR (35mm), 58
 small-format, 132
camera, selection of, 59, 61
camera, working behind, 72
camera, working in front of, 72
camera position:
 to control perspective, 63
 and focal length, 61
 for full-figure shooting, 63
 for normal perspective, 63
 for waist-up shooting, 63
Canon cameras, 59
Cartier-Bresson, Henri, 58
cast shadows, 12, 14, 17, 21, 38
Chambers, Kim Robert, *149, 159*
chemical reducer, for print touch-up, 77
clumping, of grain, 70, 73, 92
collage, 6, 166
color alteration of negative. *See* Filters
color alteration of print. *See* Tone alteration
color brightness chart, 88
color complement, 66
 See also Subtractive primary
color perception:
 in black-and-white photography, 92
 emotional impact of, 92
 as visual element, 92

F

G

M

N

O

P

Q

R